COCA-COLA
Trays

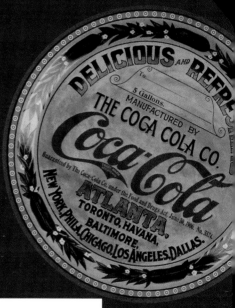

WILLIAM McCLINTOCK

Revised & Expanded 2nd Edition

Schiffer Publishing Ltd

4880 Lower Valley Road, Atglen, PA 19310 USA

Library of Congress Cataloging-in-Publication Data

McClintock, William.
Coca-cola trays / William McClintock.--Rev. & expanded 2nd ed.
p. cm.
ISBN 0-7643-0984-6 (pbk.)
1. Coca-Cola Company—Collectibles—Catalogs. 2. Advertising trays—Collectors and collecting—
United States—Catalogs.
I. Title.
NK808.M42 2000

741.6'7'0973075—dc21

99-056135
CIP

Revised price guide: 2000
Copyright © 1996 & 2000 by William McClintock

All rights reserved. No part of this work may be reproduced or used in any form or by any means—graphic, electronic, or mechanical, including photocopying or information storage and retrieval systems—without written permission from the copyright holder.
"Schiffer," "Schiffer Publishing Ltd. & Design," and the "Design of pen and ink well" are registered trademarks of Schiffer Publishing, Ltd.

ISBN: 0-7643-0984-6
Printed in China
1 2 3 4

Published by Schiffer Publishing Ltd.
4880 Lower Valley Road
Atglen, PA 19310
Phone: (610) 593-1777; Fax: (610) 593-2002
E-mail: Schifferbk@aol.com
Please visit our web site catalog at
www.schifferbooks.com

In Europe, Schiffer books are distributed by
Bushwood Books
6 Marksbury Avenue Kew Gardens
Surrey TW9 4JF England
Phone: 44 (0)181 392-8585;
Fax: 44 (0)181 392-9876
E-mail: Bushwd@aol.com

This book may be purchased from the publisher.
Include $3.95 for shipping. Please try your bookstore first.
We are interested in hearing from authors with book ideas on related subjects.
You may write for a free printed catalog.

ACKNOWLEDGMENTS

I would like to thank Billy Paul, president of the central Florida chap ter of the Coca-Cola Collectors Club, for encouraging me to write this book. I am also indebted to the Schmidt Coca-Cola Museum of Elizabethtown, Kentucky for allowing me to copy photographs from their extensive collection in order to show the first sixty trays in this book.

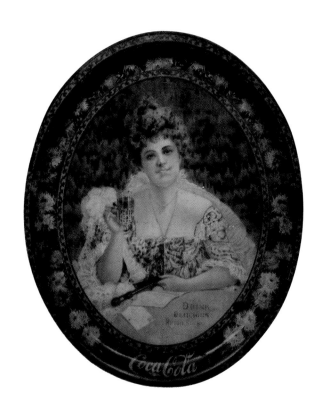

CONTENTS

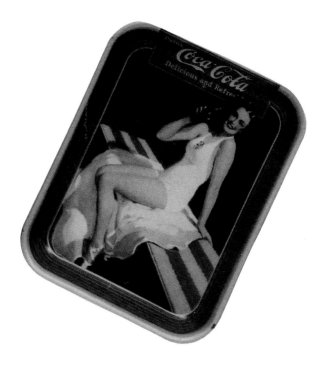

INTRODUCTION

The Coca-Cola Company started issuing serving trays and change trays in 1897. Almost immediately, people began collecting them.

Traditionalists consider 1968 to be the end of the era that began in 1897. The prices of those trays range from a few hundred to many thousands of dollars. The cost and availability of those trays has left out many a would-be collector.

In 1970, a new era in tray products began. New materials, sizes, shapes and lower costs have made it possible for all collectors to enjoy the thrill of tray-collecting. I call the new collector "The New Age Collector."

The New Age Collector has just as many problems and thrills of the hunt as the traditionalist, plus one additional problem: the fake or unauthorized issued tray.

Trays are produced in Mexico, Italy, Canada, Taiwan and the United States. Since 1970, approximately 250 trays have been issued by the above countries. Only those from Canada and the United States will be discussed in this book.

To my knowledge, there is no official count of the number of trays currently in existence. Information in this book is from the author's personal knowledge, accumulated in almost thirty years of collecting trays.

Over the years I have contacted the archives section, marketing division, and legal division of the Coca-Cola Company. No one in these divisions kept records of the yearly production of trays throughout the world. They consult the books already in existence for any information they desire.

It is my opinion that I have discovered 90% of all American and Canadian trays existing at this point. My personal collection will never be complete, though, which is the exciting part for me. There is always one more tray to be discovered from a year previously thought complete.

The prices listed in this book are based on mint conditions and availability. I feel the prices are fair but advise new collectors to remember: "Let the buyer beware." I have listed sources to find trays at reasonable prices in a later section of this book.

Where you begin your collection is a matter of personal taste. You can try to collect them all or specialize in one area. The following is a list of categories that contain a number of trays:

The 75th anniversary
Vehicles
Colleges
Cities
National conventions
Annual festivities
Reproductions
Santas
Bottle plant anniversaries
Rockwells
Olympics
Women

AUTHENTICITY

The biggest questions asked by new collectors are "Did I buy a fake?" or "Is it the real thing?" Trays can be classified into the following categories:

Authorized: Usually has the official Coca-Cola product label on the rear, is dated, and has a message about the tray on the rear.

Commemorative: Dated, with some type of description or history of the tray. Has the official blessing of the Coca-Cola Company.

Unauthorized: Usually mass-produced at an unknown location. Usually no date or information about the tray can be found, and no permission has been granted by the Coca-Cola Company for production of the tray.

Unknown: Probably authorized but due to lack of information the tray cannot be easily verified. Usually made for a local event.

In many current or past books dealing with Coca-Cola products, you will see discussions of 'Fantasy' or the unauthorized tray. They are often considered worthless and not to be taken seriously by the collector. My advice comes from almost thirty years of collecting trays, and is simple: If you like it, buy it. I bought several trays in the 1970s for $5 that are now considered unique and sought-after. One set is now listed to be worth $100!

Many companies have been involved in the manufacture of Coke trays. Most of the time they are not noted on the tray, but it really would add no significance other than helping in identification. The two most notable companies are the Ohio Art Company and Markatron.

COCA-COLA
RESOURCES

Those of you getting started in your collecting might find it difficult to locate trays. The following is a list of sources I have used or know to be trustworthy, who generally offer a good selection of trays:

The Coca-Cola Collectors Club, P.O. Box 49166, Atlanta, Georgia 30359-1166. Membership is $25 a year for twelve issues of their magazine. I highly recommend it.

Pop's Mail Order Collectibles, 4439 Hudgins Street, Memphis, Tennessee 38116. A catalog will be sent to you with the fairest prices I have seen over the years.

The World of Coca-Cola Museum, 55 Martin Luther Drive, Atlanta, Georgia.

The Coca-Cola Catalog, 2515 43rd Street, P.O. Box 182264, Chattanooga, Tennessee 37422.

Coca-Cola stores; most big towns now have stores that deal specifically in Coke products.

Flea markets; what can I say? Prices and selection vary.

Garage sales; I know many people who do well at them.

Antique stores; prices are usually high, and selection is usually not
good. If I can't dicker I move on.

COCA-COLA FESTIVITIES

The following Coca-Cola gatherings are held around the United States. The Coca-Cola Collectors Club National Convention is held in a different state each year. Membership in the club keeps you informed about all of these meetings and dates.

January:	Canton Ohio Superbowl
February:	Ohio Winterfest, in Zanesville
	The Great Get Together, in California
	Tex-Fest, in Garland, Texas
April:	Iowa Spring Refreshment,
	in Des Moines Springtime in Atlanta
May:	Badger Spring Pause, in Wisconsin
	Smokyfest, in Gatlinburg, Tennessee
	Mid-America Spring Fling, in Missouri
June:	Sun & Fun Florida, in St. Petersburg
July:	Atlanta Convention, in Georgia
August:	Choo Choo Connection, in
	Chattanooga, Tennessee
September:	Septemberfest, in Elizabethtown,
	Kentucky

TRAY SIZES

Since 1970, many sizes or shapes of trays have been noted on the market, including deep rectangle, flat rectangle, large and small oval, round, deep oval, and TV tray. The particular style is chosen solely at the discretion of the producer. The following is a list of sizes as used in this book:

Standard	13 1/4" x 10 1/2"
Flat Standard	10 3/4" x 14 3/4"
Long Rectangular	18 3/4" x 8 1/2"
Small Rectangular	14" x 8 3/4"
Small Flat Oval	10 3/4" x 8 1/2"
Medium Flat Oval	10 1/2" x 12 3/4"
Large Flat Oval	17" x 13 3/4"
Large Square Oval	16 1/4" x 12 1/2"
Large Deep Oval	12 1/2" x 15"
Round Flat	12 1/4" x 1/4"
Deep Round	11 3/4" x 1"
Large Deep	13 1/4" x 1 3/4"

I have made every effort to make this book as accurate as possible. Any errors noted are due to lack of knowledge at the time of writing. There will always be controversy, starting with the first tray produced in 1971. It's ugly, it's plastic, and it does not look like the trays that came before or after it. It did start the new era, though, and in that regard I listed it. There are many trays I did not list due to not having a photograph or the tray in my collection. Hopefully in the future a second book will include these trays and the many more that will follow. Good luck and good hunting. I would be glad to hear from anyone with information on trays not listed here. You can contact me through the publisher of this book.

TURN OF THE CENTURY

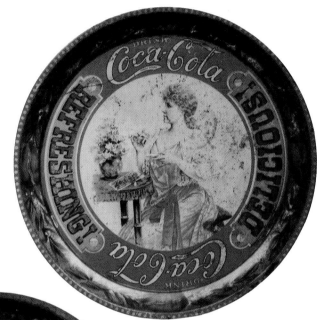

Victorian Girl
1897
Round, 9 3/8"
Value: Rare

Hilda with Pen
1899
Round, 9 5/8"
Value: Rare

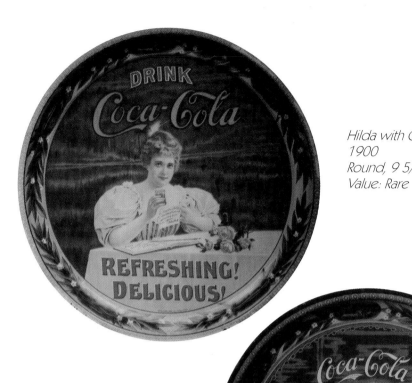

Hilda with Glass
1900
Round, 9 5/8"
Value: Rare

Hilda with Roses
1901
Round, 9 3/4"
Value: Rare

Hilda
1903
Round, 9 3/4"
Value: $3,000

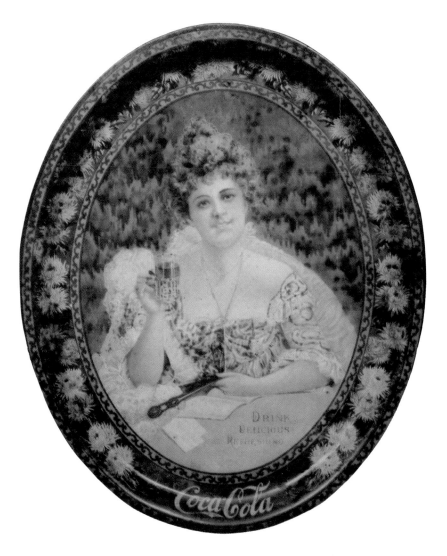

Hilda
1903
Oval, 15 1/8" x 18 5/8"
Brown tint to tray.
Value: $3,500

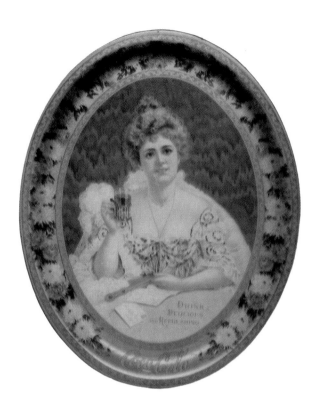

Hilda
1903
Oval, 15 1/8" x 18 5/8"
Red tint to tray.
Value: $3,500

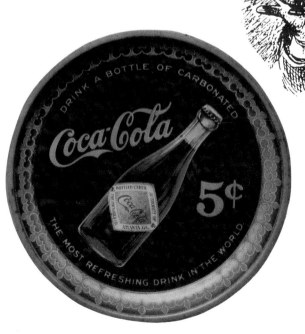

Bottle Tray
1903
Round, 9 3/4"
Value: $4,000

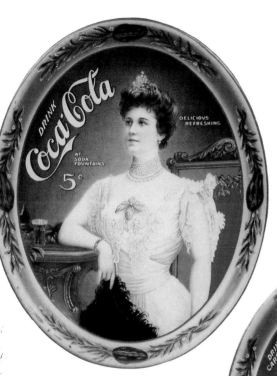

Lillian Nordica with Glass
1904
Oval, 10 5/8" x 12 7/8"
Value: $2,000

Lillian Nordica with Bottle
1904
Oval, 10 5/8" x 12 7/8"
Value: $2,000

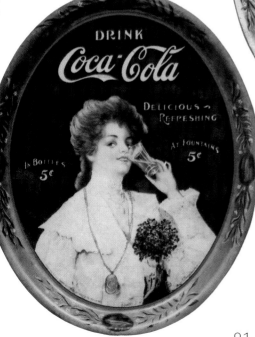

Juanita
1906
Oval, 10 7/8" x 13"
Value: $2,000

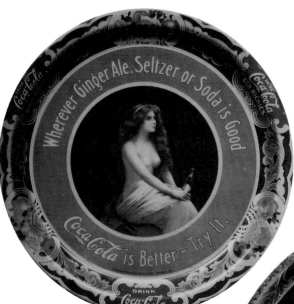

Topless
1905
Round, 12 1/4"
Value: $3,000

Relieves Fatigue
1907
Oval, 10 7/8" x 13 1/4"
Value: $1,500

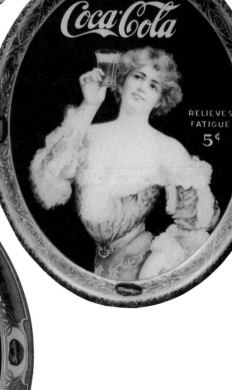

Exhibition Girl
1909
Oval, 13 5/8" x 16 5/8"
Value: $2,000

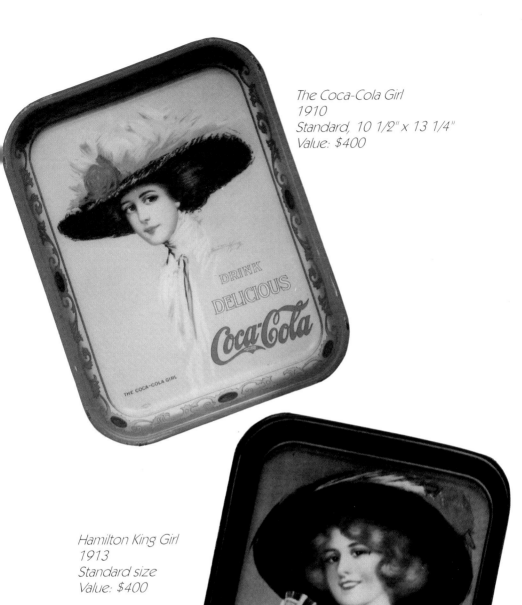

The Coca-Cola Girl
1910
Standard, 10 1/2" x 13 1/4"
Value: $400

Hamilton King Girl
1913
Standard size
Value: $400

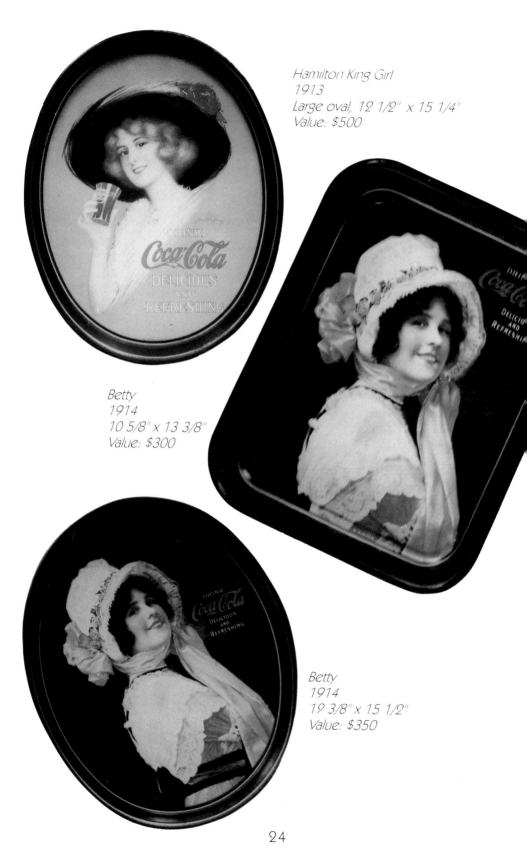

Hamilton King Girl
1913
Large oval, 12 1/2" x 15 1/4"
Value: $500

Betty
1914
10 5/8" x 13 3/8"
Value: $300

Betty
1914
19 3/8" x 15 1/2"
Value: $350

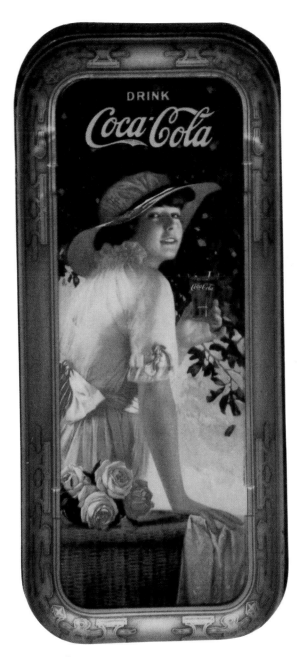

Elaine
1916
Long rectangle, 8 1/2" x 19"
Value: $300

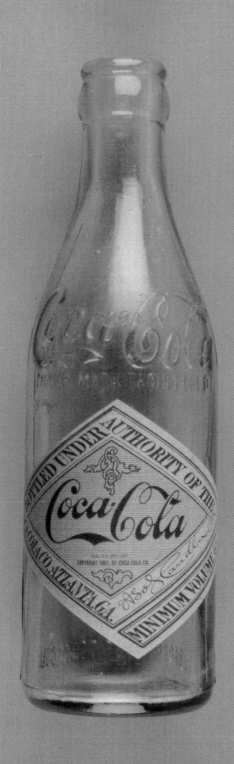

THE
1920S

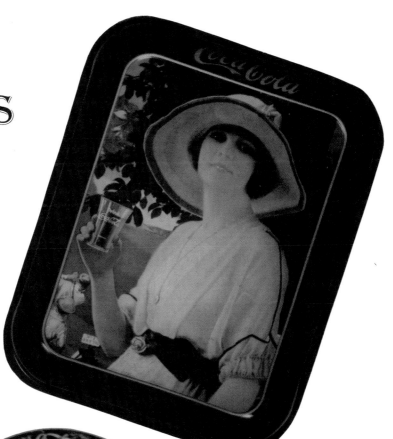

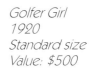

Golfer Girl
1920
Standard size
Value: $500

Golfer Girl
1921
Oval, 13 3/4" x 16 3/4"
Value: $500

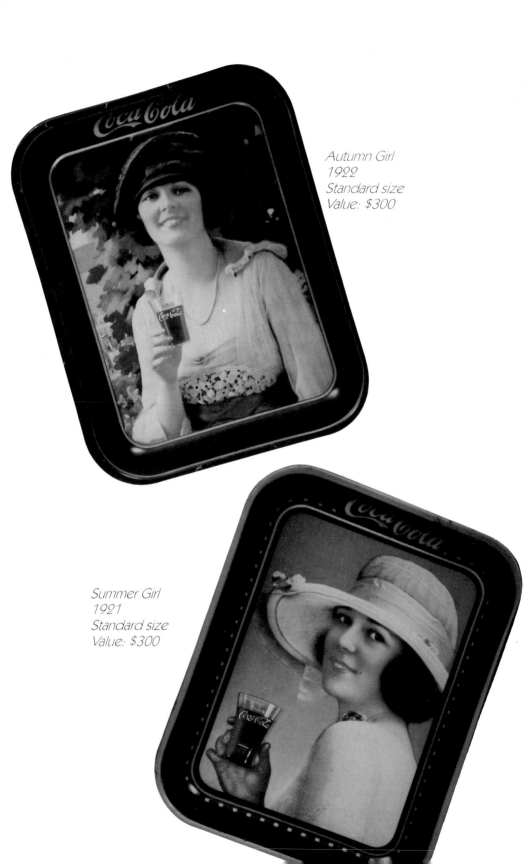

Autumn Girl
1922
Standard size
Value: $300

Summer Girl
1921
Standard size
Value: $300

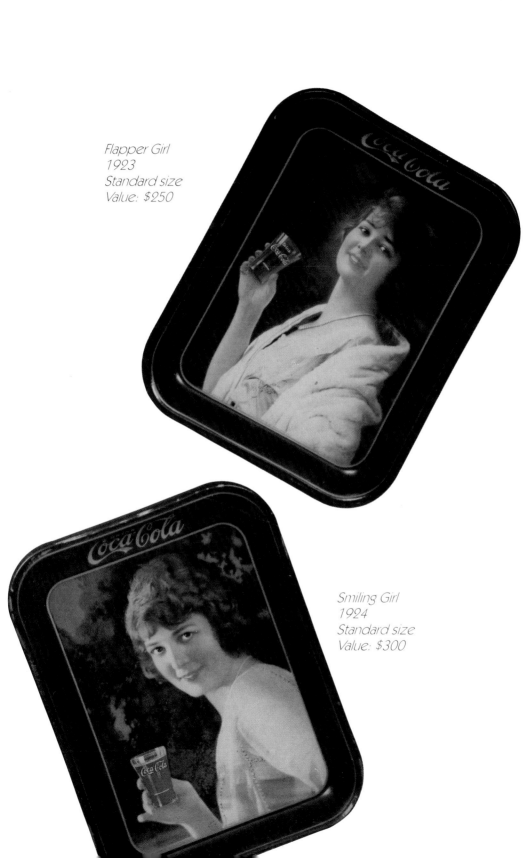

Flapper Girl
1923
Standard size
Value: $250

Smiling Girl
1924
Standard size
Value: $300

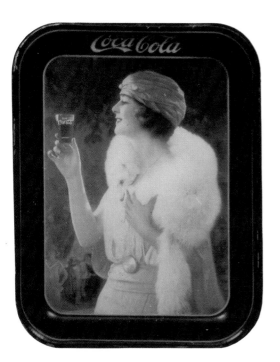

Party Girl
1925
Standard size
Value: $250

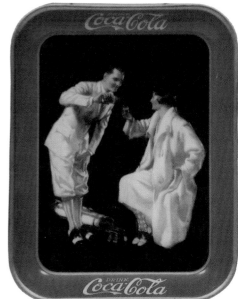

Golfers
1926
Standard size
Value: $200

Curb Service
1927
Standard size
Value: $250

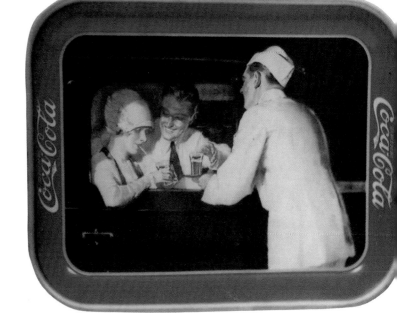

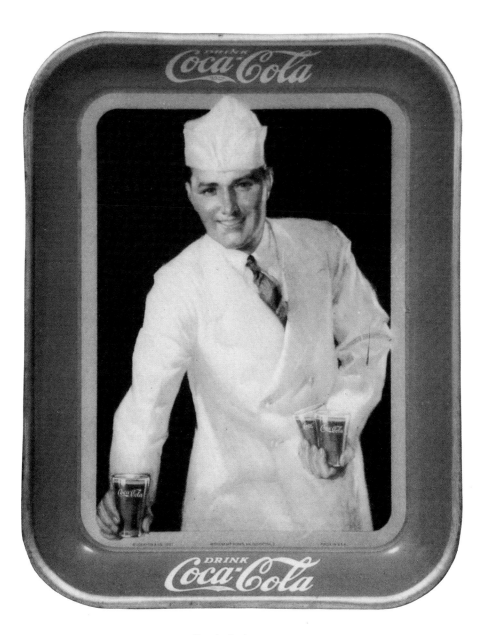

Soda Jerk
1927
Standard size
Value: $250

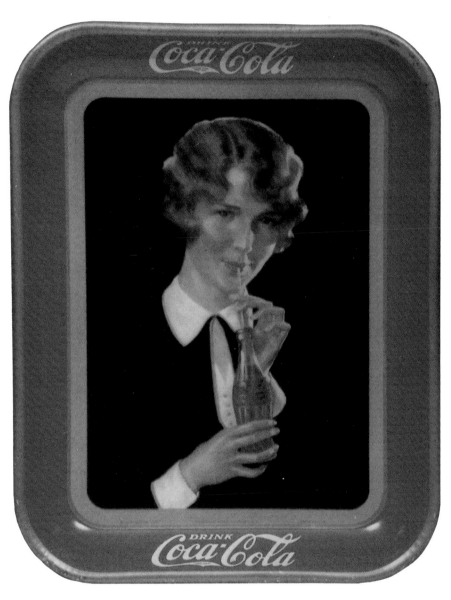

Girl with Bobbed Hair
1928
Standard size
Value: $200

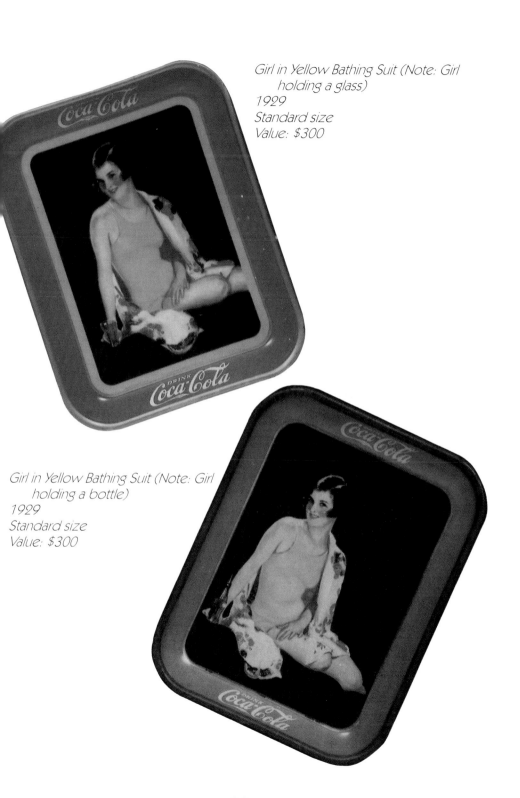

*Girl in Yellow Bathing Suit (Note: Girl
 holding a glass)*
1929
Standard size
Value: $300

*Girl in Yellow Bathing Suit (Note: Girl
 holding a bottle)*
1929
Standard size
Value: $300

THE
1930S

Telephone Girl
1930
Standard size
Value: $200

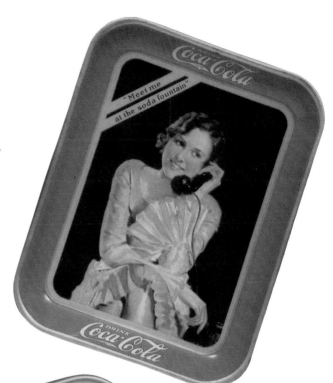

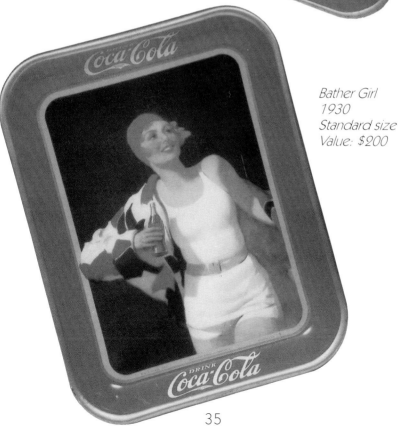

Bather Girl
1930
Standard size
Value: $200

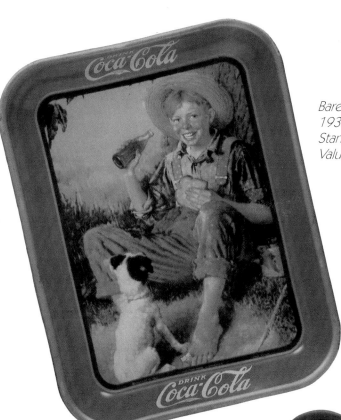

Barefoot Boy
1931
Standard size
Value: $300

Girl in Bathing Suit
1932
Standard size
Value: $200

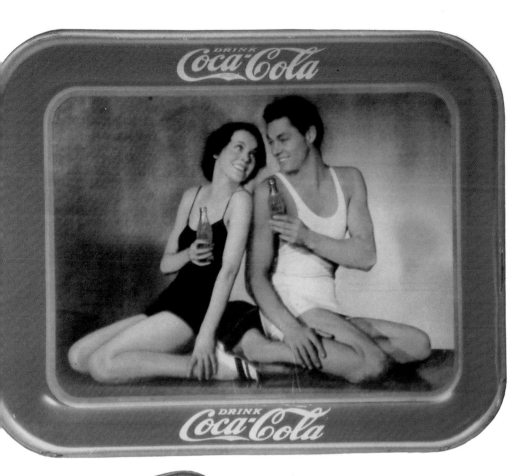

Tarzan
(Johnny Weismuller and
Maureen O'Sullivan)
1934
Standard size
Value: $350

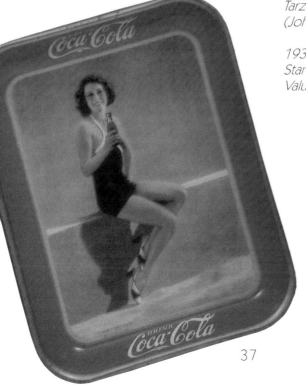

Frances Dee
1933
Standard size
Value: $175

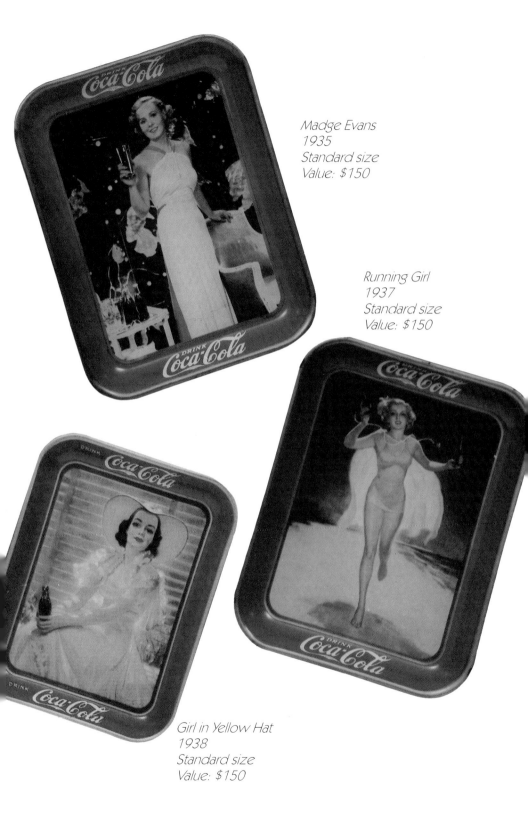

Madge Evans
1935
Standard size
Value: $150

Running Girl
1937
Standard size
Value: $150

Girl in Yellow Hat
1938
Standard size
Value: $150

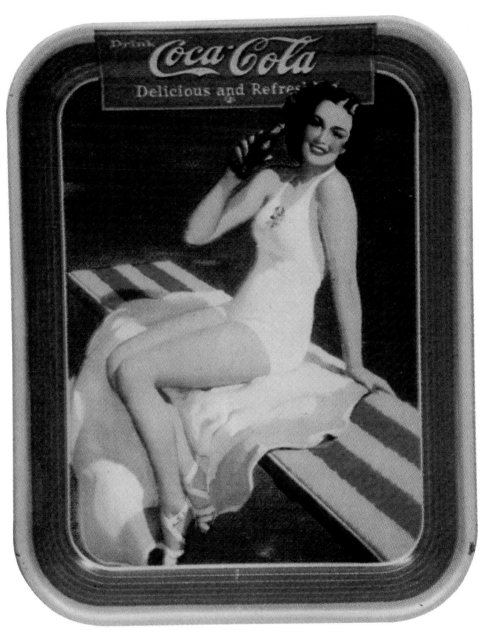

Springboard Girl
1939
Standard size
Value: $175

THE
1940S

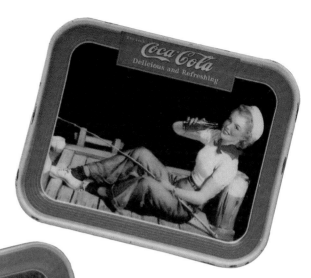

Skater Girl
1941
Standard size
Value: $150

Sailor Girl
1940
Standard size
Value: $150

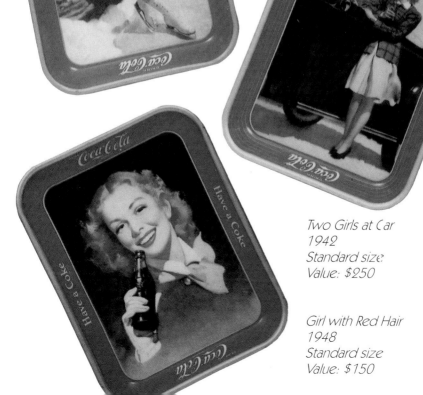

Two Girls at Car
1942
Standard size
Value: $250

Girl with Red Hair
1948
Standard size
Value: $150

THE 1950S

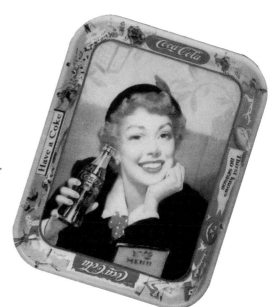

Menu Girl
1950
Standard size
Value: $85

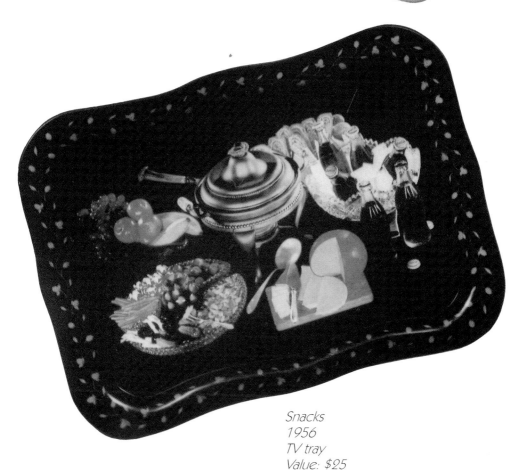

Snacks
1956
TV tray
Value: $25

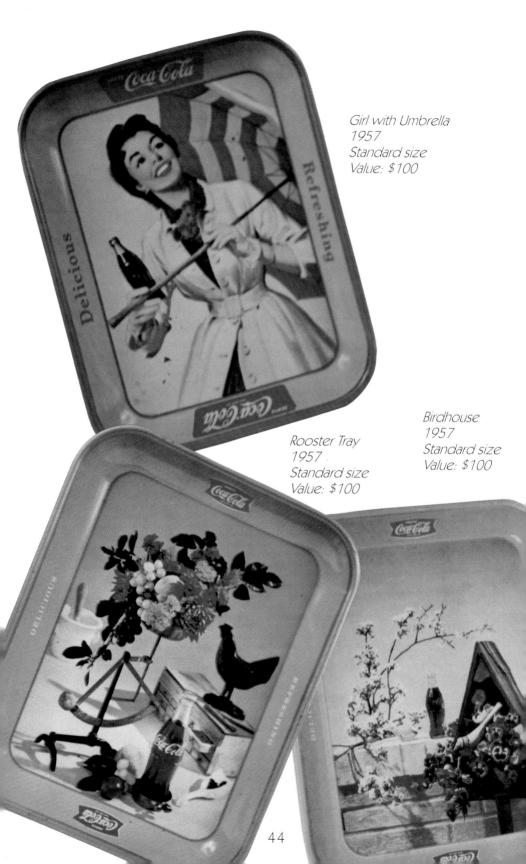

Girl with Umbrella
1957
Standard size
Value: $100

Rooster Tray
1957
Standard size
Value: $100

Birdhouse
1957
Standard size
Value: $100

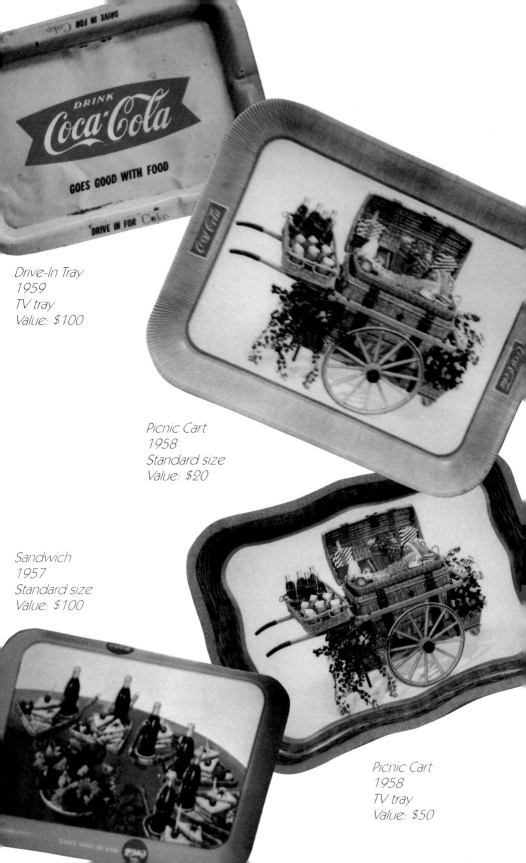

Drive-In Tray
1959
TV tray
Value: $100

Picnic Cart
1958
Standard size
Value: $20

Sandwich
1957
Standard size
Value: $100

Picnic Cart
1958
TV tray
Value: $50

THE 1960S

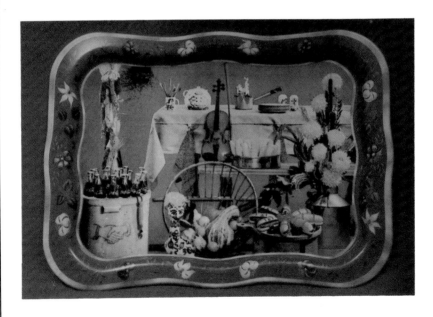

Thanksgiving Scene
1960
TV tray
Value: $20

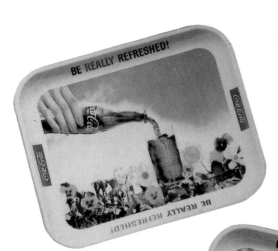

Pansy Garden
1961
Be Really Refreshed
Value: $20

Pansy Garden
1961
Be Really Refreshed
(Fishtail)
Value: $20

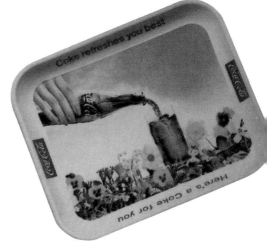

Coke Refreshes You Best
1961
Standard size
Value: $20

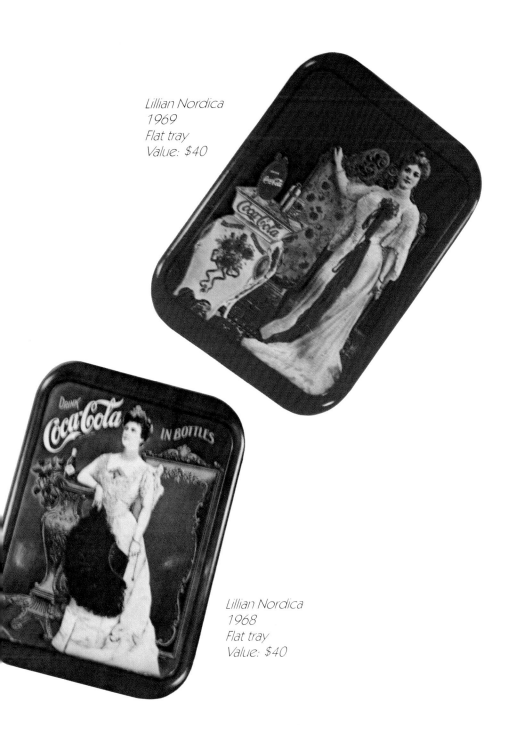

Lillian Nordica
1969
Flat tray
Value: $40

Lillian Nordica
1968
Flat tray
Value: $40

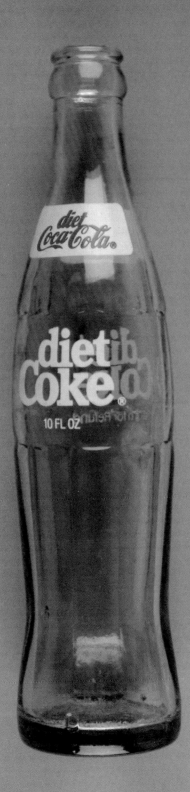

THE
1970S

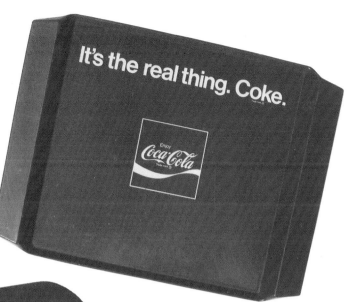

It's The Real Thing Coke
1971
Plastic
No date, no story
Value: $10

Hamilton King Girl
1971
Standard flat
Rim dated, no information on
 the tray.
Value: $15

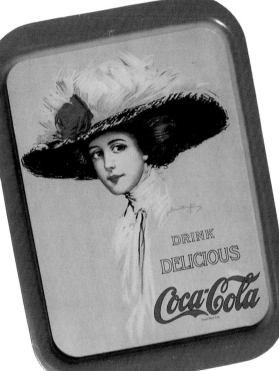

Duster Girl
1971
Flat
No date, no story
Value: $5

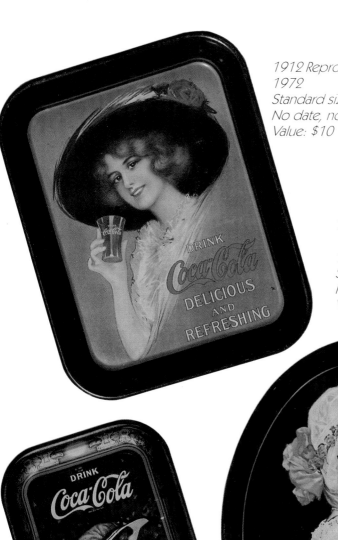

1912 Reproduction
1972
Standard size
No date, no story
Value: $10

1914 Betty
 Reproduction
1972
Standard size
No date, no story
Value: $10

1917 Reproduction
1972
Standard size
No date, no story
Value: $10

52

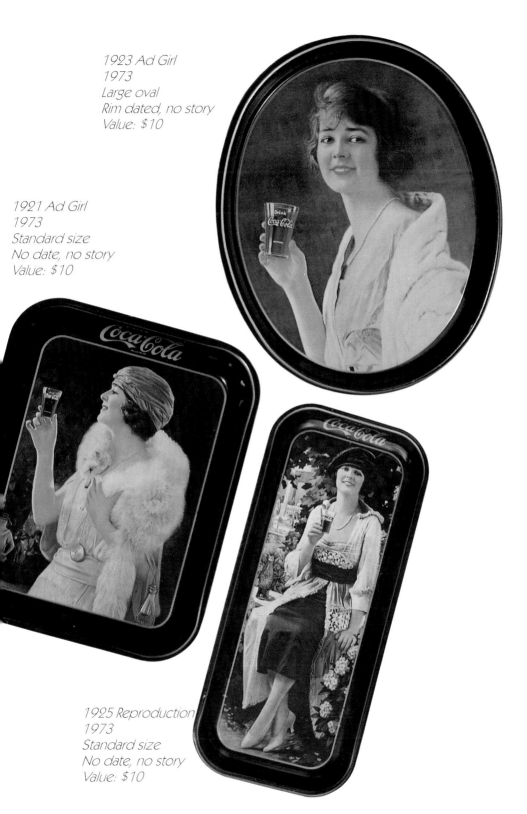

1923 Ad Girl
1973
Large oval
Rim dated, no story
Value: $10

1921 Ad Girl
1973
Standard size
No date, no story
Value: $10

1925 Reproduction
1973
Standard size
No date, no story
Value: $10

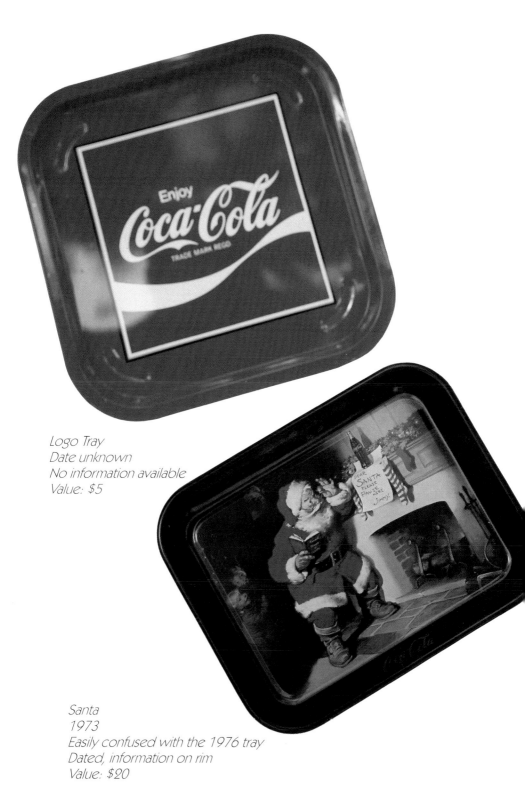

Logo Tray
Date unknown
No information available
Value: $5

Santa
1973
Easily confused with the 1976 tray
Dated, information on rim
Value: $20

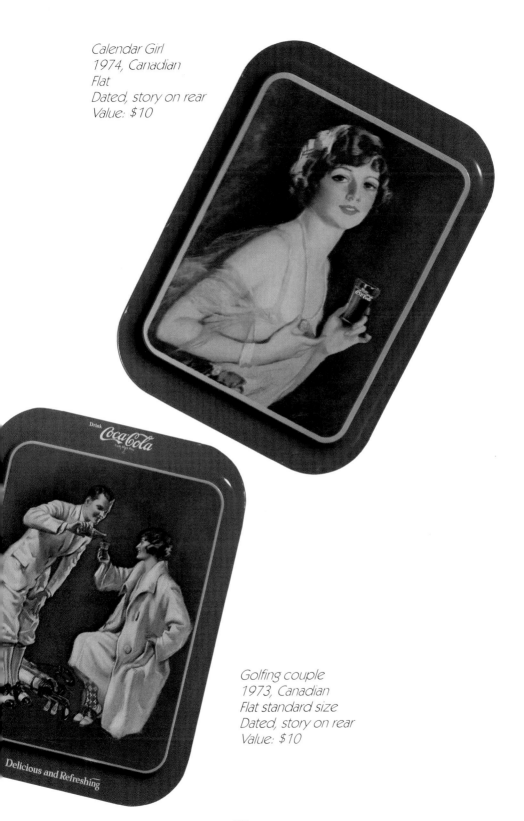

Calendar Girl
1974, Canadian
Flat
Dated, story on rear
Value: $10

Golfing couple
1973, Canadian
Flat standard size
Dated, story on rear
Value: $10

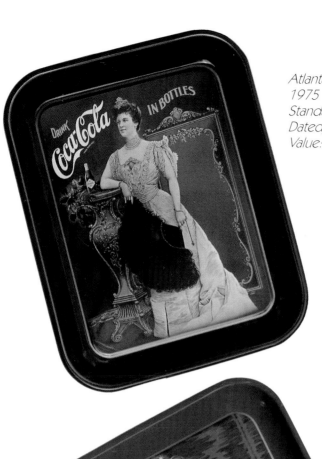

Atlanta 75th–Lillian Nordica
1975
Standard size
Dated, story on rear
Value: $10

Nashville 75th–Hilda with
Roses
1975
Standard size
Dated, story on rear
Value: $15

Elaine
1976, Canadian
Small oval
Dated
Value: $10

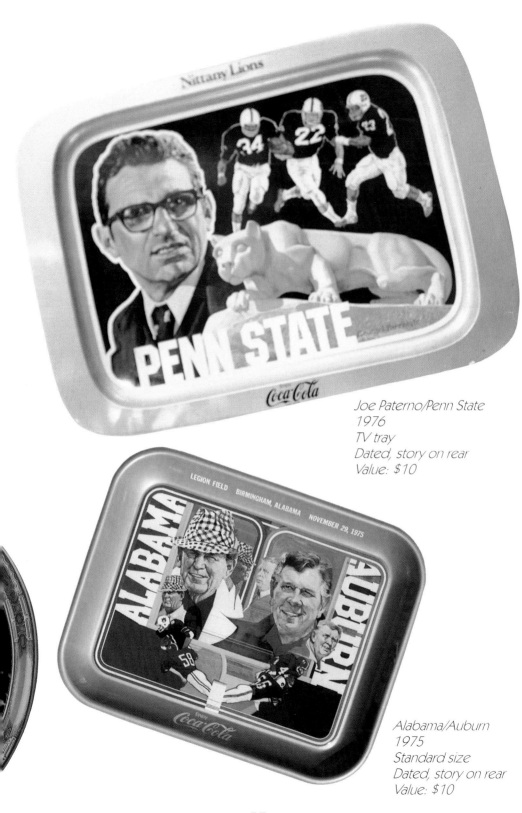

Joe Paterno/Penn State
1976
TV tray
Dated, story on rear
Value: $10

Alabama/Auburn
1975
Standard size
Dated, story on rear
Value: $10

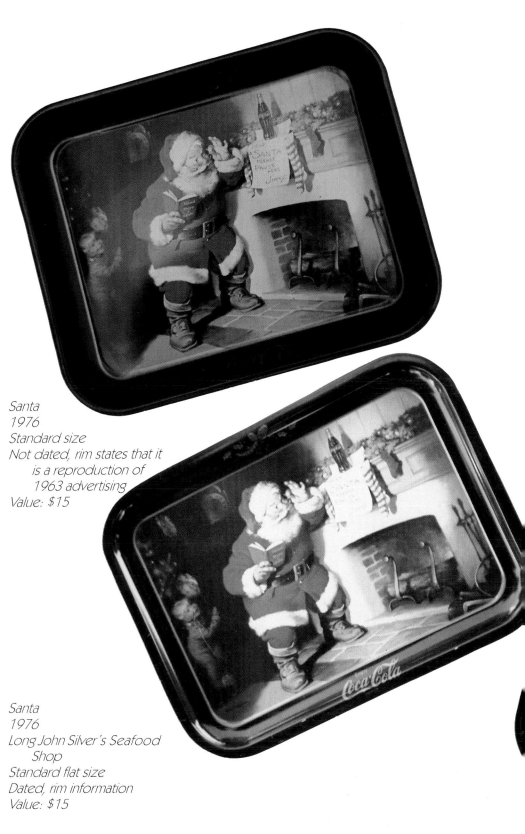

Santa
1976
Standard size
Not dated, rim states that it
 is a reproduction of
 1963 advertising
Value: $15

Santa
1976
Long John Silver's Seafood
 Shop
Standard flat size
Dated, rim information
Value: $15

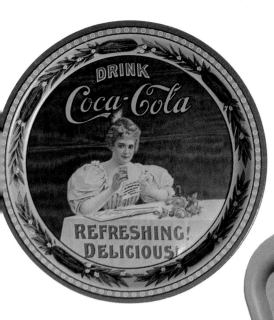

Hilda
1976
Flat round
Dated, story on rear
75th anniversary tray for Norfolk,
 Louisville, and Cincinnati
Value: $5

1976 Olympics
1976
Standard flat size
Dated, story on rear
Value: $10

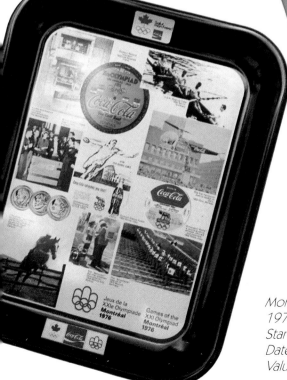

Montreal Olympics VIP
1976
Standard size
Dated, story on rear
Value: $100

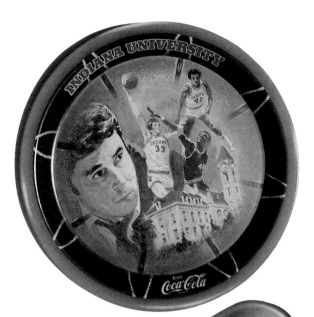

Indiana University National
Champs
1976
Flat round
Dated, story on rear
Value: $5

Arkansas Cotton Bowl
Champs
1976
Standard size
Dated, story on rear
Value: $10

Tarzan Reproduction
(Johnny Weismuller and
Maureen O'Sullivan)
1976
Standard size
No date, no story
Value: $20

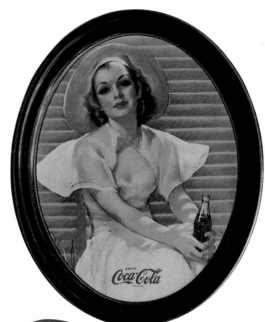

1938 Calendar Girl
1977, Canadian
Flat Oval
Dated, information on
rim
Value: $10

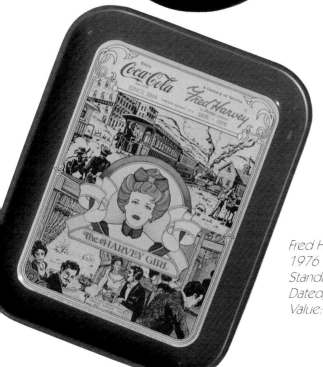

Fred Harvey Girl
1976
Standard size
Dated, story on rear
Value: $10

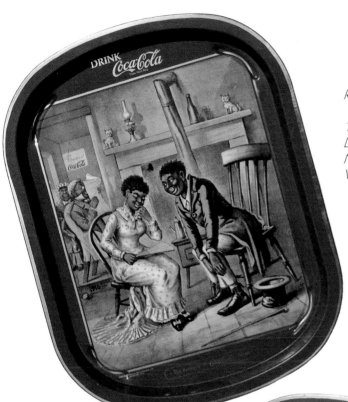

Romance of
 Coca-Cola #1
1977
Large square oval
No date, no story
Value: $25

Romance of
 Coca Cola #2
1976
Large square oval
No date, no story
Value: $25

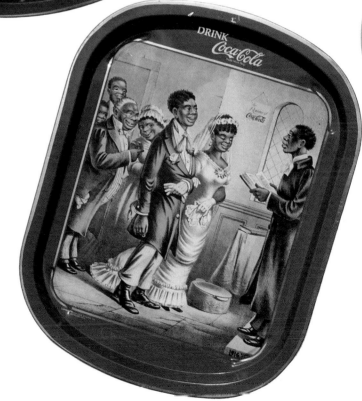

Elaine
1977, Canadian
Large oval
No date; information on rim
of the tray
Value: $10

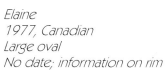

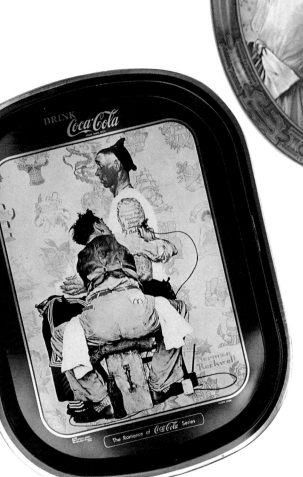

Tattoo Artist, by Norman
Rockwell
1977
Large square oval
No date
Produced by a mineral water
company
Value: $25

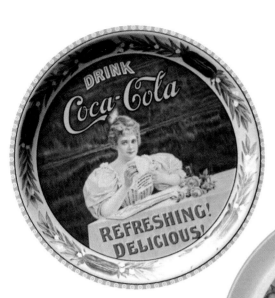

Hilda
1977
Round flat
Dated, story on rear
75th anniversary tray for Philadephia,
 PA, Augusta, Dallas, Meridan and
 Harrisburg
Value: $5

Coke Adds Life To
1977
Deep round, plastic
No date, no information on tray
Value: $5

Los Angeles 75th
1977
Round, heavy metal
Dated
Value: $30
in presentation box, $50

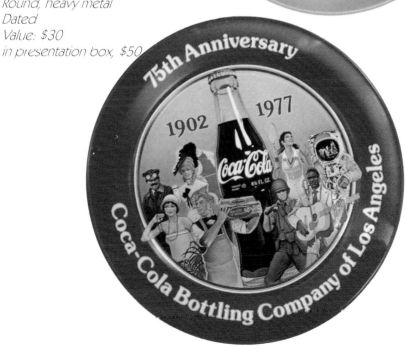

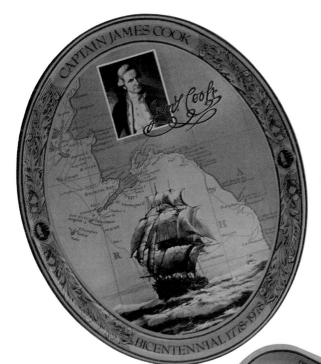

*Captain Cook
 Bicentennial
1978, Canadian
Flat oval
Dated, story on rear
Value: $15*

*Edmonton Common-
 wealth Games
1978
Standard size
No date; story on rear
Value: $40*

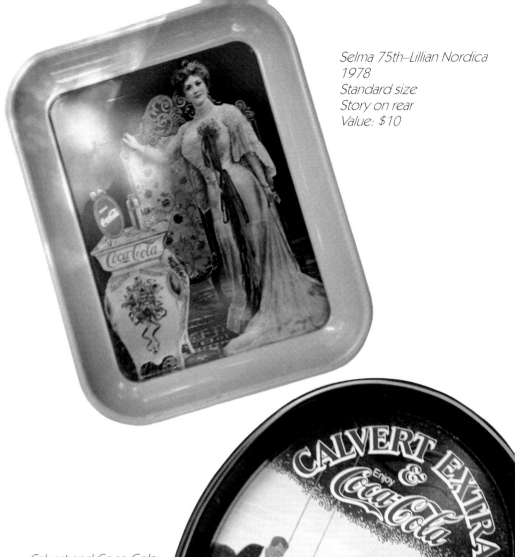

Selma 75th–Lillian Nordica
1978
Standard size
Story on rear
Value: $10

Calvert and Coca-Cola
1978
Large oval
No date, no story
Value: $5

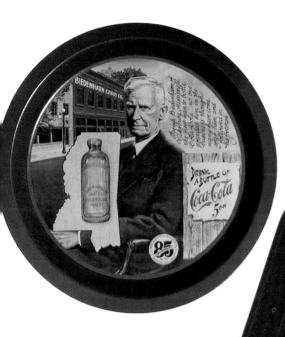

Vicksburg 75
1979
Biedenharn Candy Company
Flat round
Dated, story on rear
Value: $5

Chattanooga 80th–Lillian Nordica
1979
Standard size
Dated, story on a rear
Value: $5

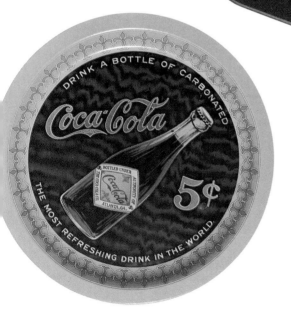

Lillian Nordica
1979, Canadian version
Flat regular
Rim information only
Value: $10

Paducah 75th
1978
Flat round
Dated, story on rear
Also anniversary tray for Athens,
 GA; Jackson and Columbia,
 MS; and Carolina
Value: $5

1928
1996
60 YEARS OF
OLYMPIC SUPPORT

Coca-Cola
CLASSIC

Trademark ®

12 FL OZ (355 mL)

THE
1980S

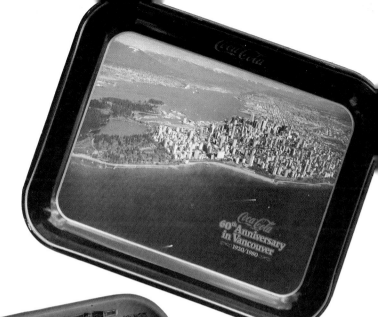

*Vancouver 60th
1980
Standard size
Dated, no story
Value: $10*

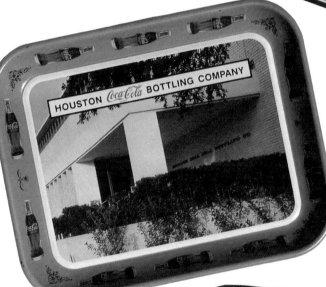

*Houston Bottling
Company
1980 Standard size
Dated, story on rear
Value: $10*

*Cleveland Bottling 75th
1980
Standard size
Dated, story on rear
Value: $10*

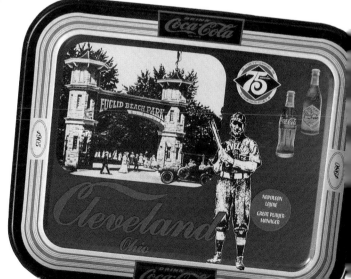

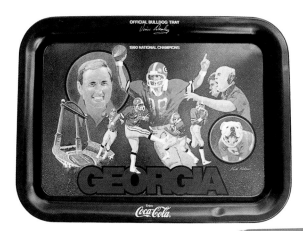

Georgia Bulldogs 1980 Champs
1980
TV tray
Dated, story on rear
Value: $10

Alberta 75th/Normandeau Cup
1980
Standard size
Dated, story on rear
Value: $20

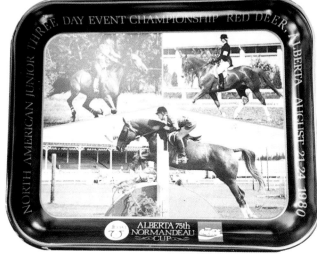

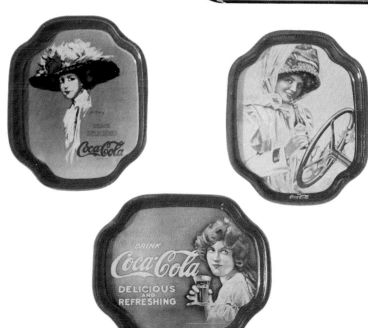

Tip Trays
1980s
Unauthorized
Value: $1 ea.

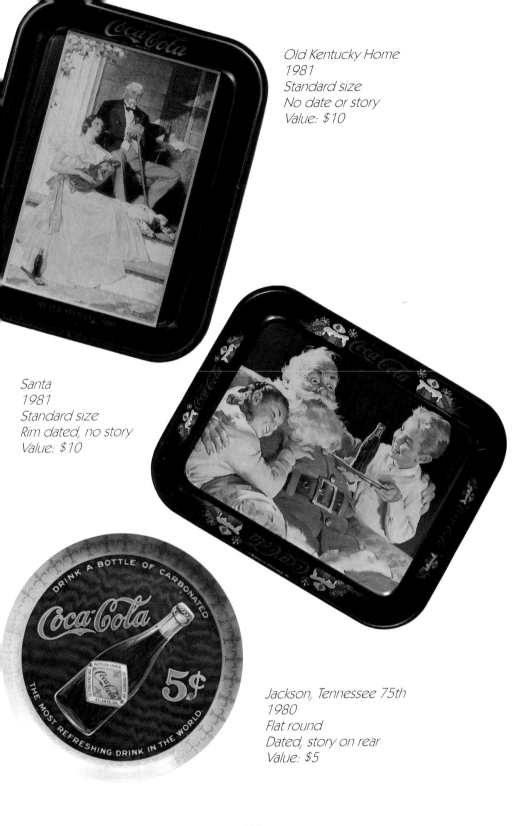

Old Kentucky Home
1981
Standard size
No date or story
Value: $10

Santa
1981
Standard size
Rim dated, no story
Value: $10

Jackson, Tennessee 75th
1980
Flat round
Dated, story on rear
Value: $5

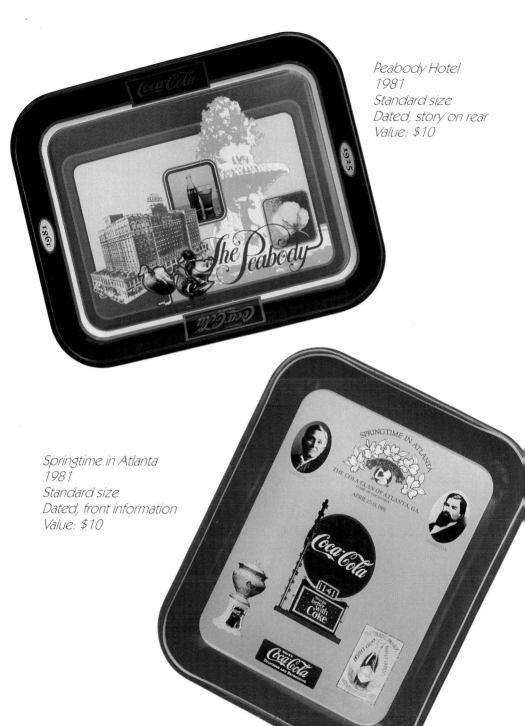

Peabody Hotel
1981
Standard size
Dated, story on rear
Value: $10

Springtime in Atlanta
1981
Standard size
Dated, front information
Value: $10

Tullahoma 75th
1981
Standard size
Dated, story on rear
Value: $5

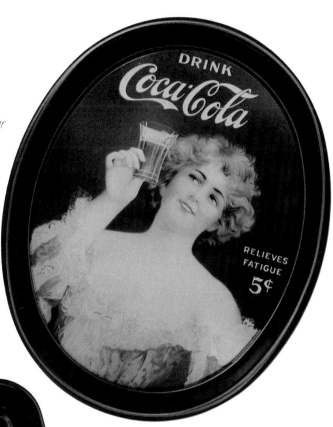

Old Oaken Bucket, by Norman
Rockwell
1981
Standard size
No date, no story
Value: $5

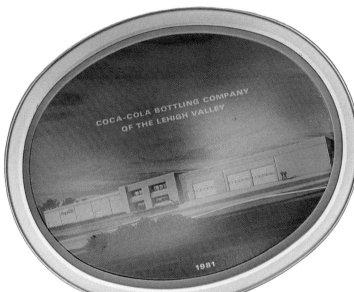

Lehigh Valley Bottling
Co.
1981
Flat oval
Dated, story on rear
Value: $5

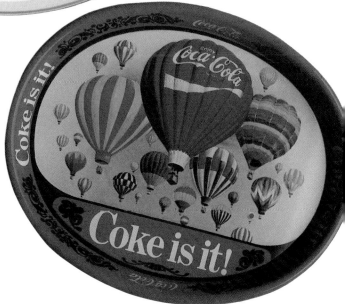

Coke Is It Balloons
1981
Large oval
No date, no story
Value: $10

Cola Clan 7th
1981
Large oval
Dated, story on rear
Value: $20

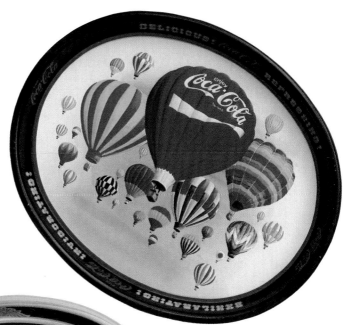

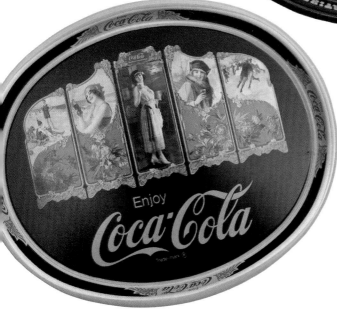

Four seasons
1981
Deep oval
Dated, no story
Value: $5

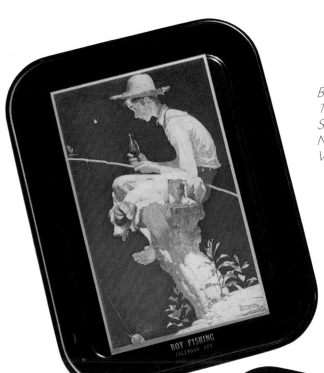

Boy Fishing, by Norman Rockwell
1981
Standard size
No date, no story
Value: $5

1981 Calendar
1981
TV tray
Front dated, no story
Value: $10

Coke Is It / Handles
On Tray
1981
No date, no information
Value: $10

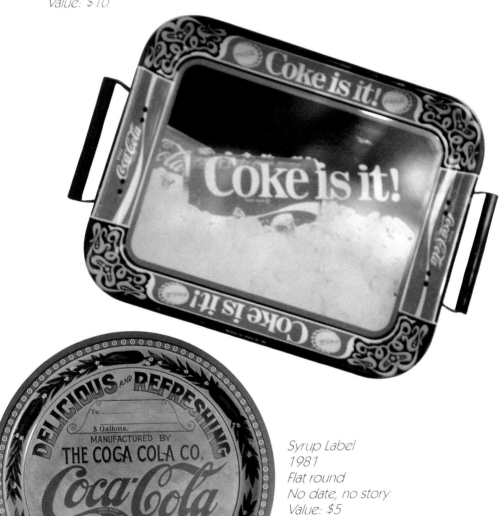

Syrup Label
1981
Flat round
No date, no story
Value: $5

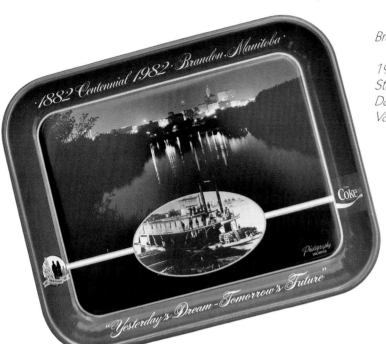

Brandon Manitoba
Centennial
1982
Standard size
Dated, story on rear
Value: $10

McDonald's Convention
1982
Standard size
Dated, no story
Value: $100

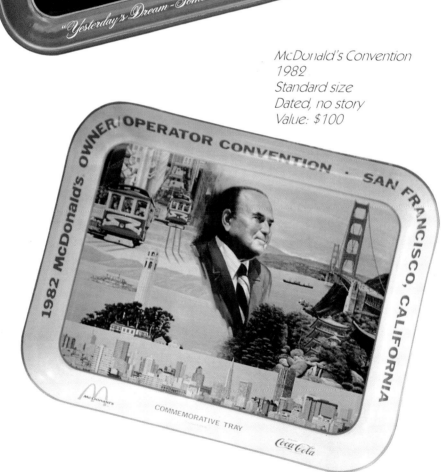

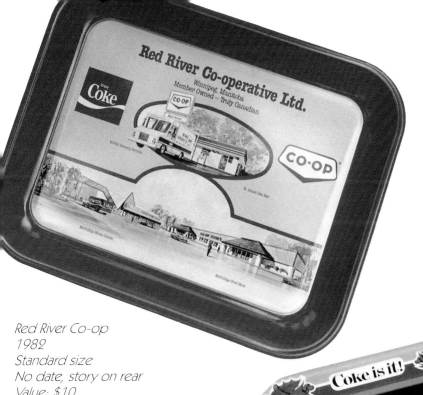

Red River Co-op
1982
Standard size
No date, story on rear
Value: $10

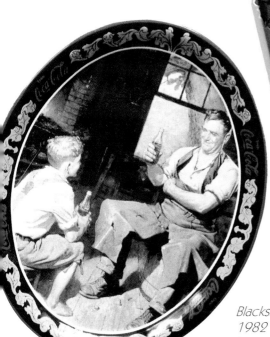

Blacksmith
1982
Large oval
Dated, no story
Value: $5

Santa with Elves
1982
Standard size
Dated, no story
Value: $15

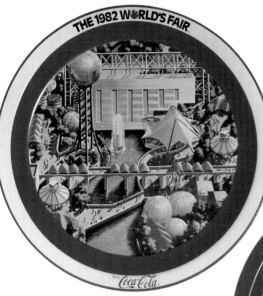

World's Fair
1982
Flat round
Dated, story on rear
Value: $5

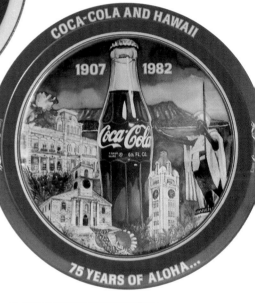

Hawaii 75th
1982
Flat round
Dated, story on rear
Value: $5

Pembroke Bottling Plant
1982
Standard size
Dated, no story
Value: $100

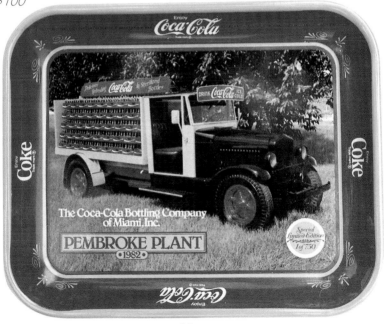

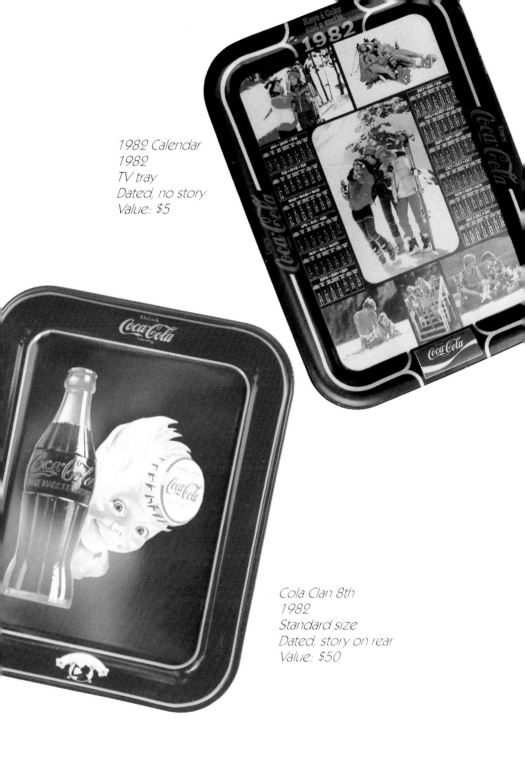

1982 Calendar
1982
TV tray
Dated, no story
Value: $5

Cola Clan 8th
1982
Standard size
Dated, story on rear
Value: $50

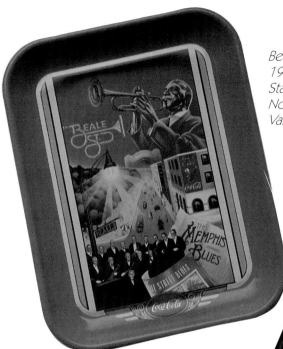

Beale Street
1983
Standard size
No date, story on rear
Value: $10

Santa
1983
Standard size
Dated, rim information
Value: $15

Santa with Child
1983
Standard size
Dated, no story
Value: $15

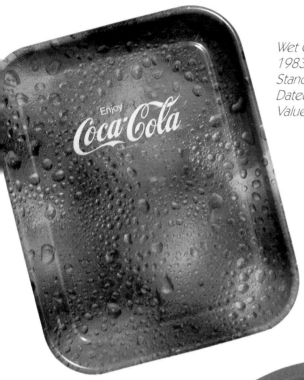

Wet Coke
1983
Standard size
Dated, no story
Value: $10

Cola Clan 9th Convention
1983
Flat round
Dated, story on rear
Value: $10

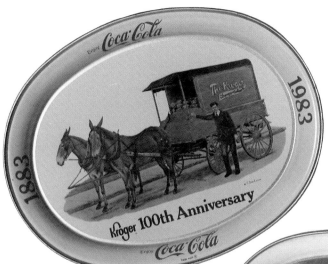

Kroger 100th
1983
Small oval
Dated, story on rear
Value: $5

Cola Clan 10th,
 Sacramento
1984
Small oval
Dated, story on rear
Value: $5

Memphis Special Train
1984
Standard size
Non-dated, story on rear
Value: $6

Memphis Chicks
1984
Standard size
No date, no story
Value: $5

Through the Years
1984
Standard size
No date, no story
Value: $5

Memphis, Tennessee
1984
TV tray
No date; story on
 rear
Value: $6

Zanesville, Ohio–
 Y Bridge
1984
Standard size
Dated, story on rear
Value: $20

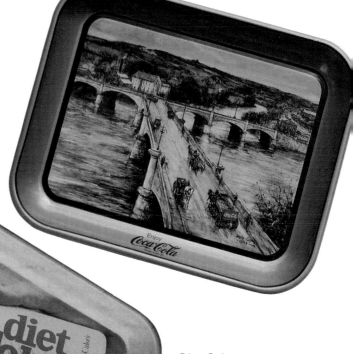

Diet Coke
1984
Standard size
No date, no story
Value: $7

USA Olympics
1984
Large Oval
Dated, story on rear
Value: $15

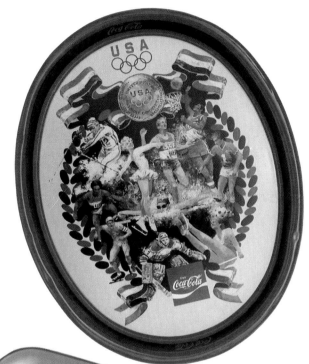

Big Bear Santa
1984
TV tray
No date; story on rear
Value: $10

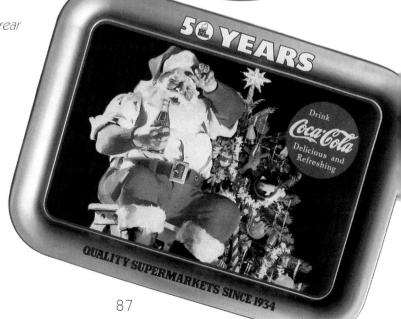

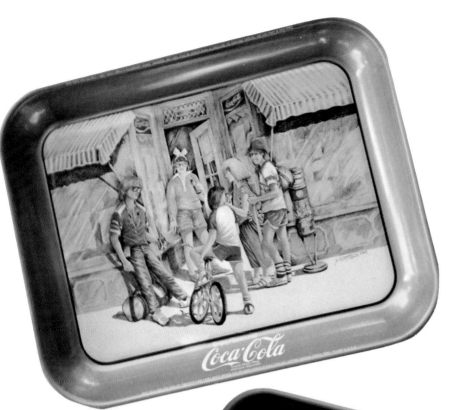

*Kids in Front of Gro-
cery Store
1984, Canadian
Standard size
Dated, no story
Value: $10*

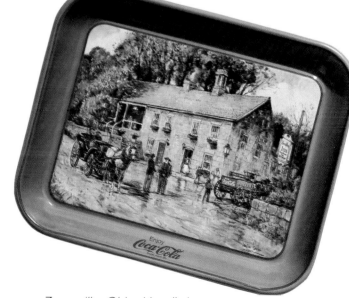

*Zanesville, Ohio–Headly Inn
1985
Standard
Dated, story on rear
Value: $20*

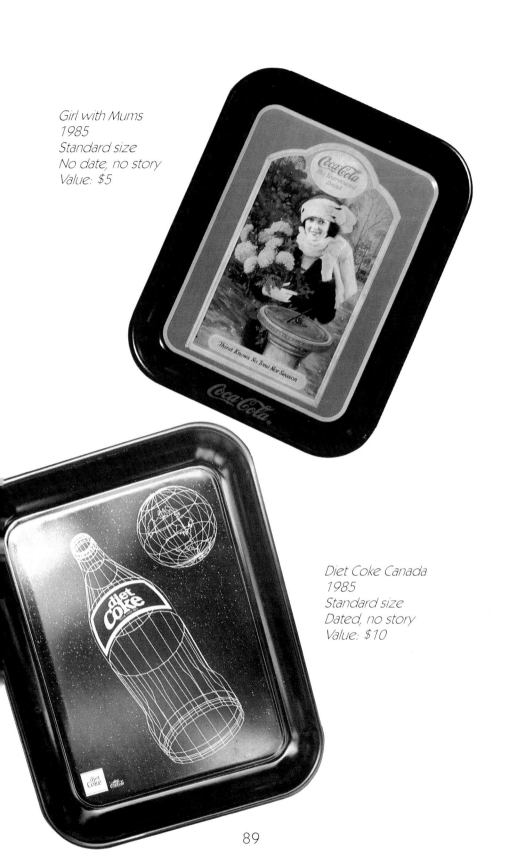

Girl with Mums
1985
Standard size
No date, no story
Value: $5

Diet Coke Canada
1985
Standard size
Dated, no story
Value: $10

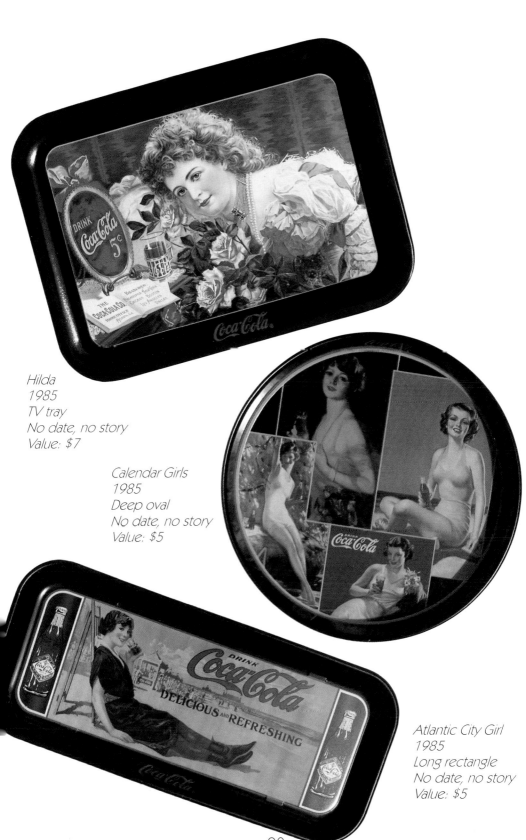

Hilda
1985
TV tray
No date, no story
Value: $7

Calendar Girls
1985
Deep oval
No date, no story
Value: $5

Atlantic City Girl
1985
Long rectangle
No date, no story
Value: $5

Duster Girls
1985
Large oval
No date, no story
Value: $5

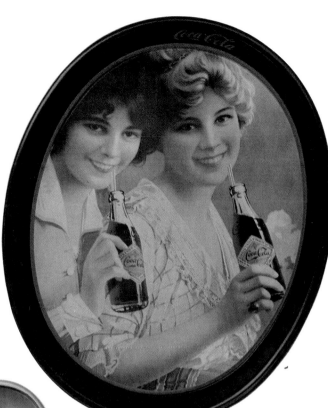

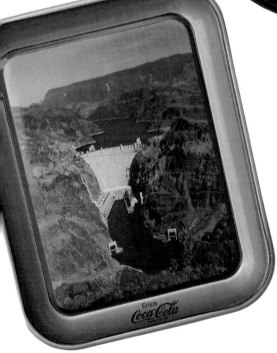

Hoover Dam 50th
1985
Standard size
Dated, story on rear
Value: $5

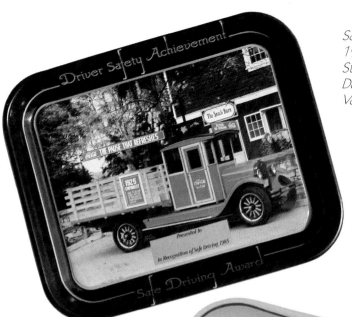

Safe Driving Award
1985
Standard size
Dated, no story
Value: $20

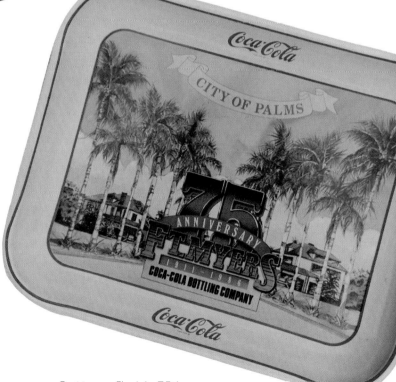

Ft. Myers, Florida 75th
1986
Standard size
Dated, no story
Value: $10

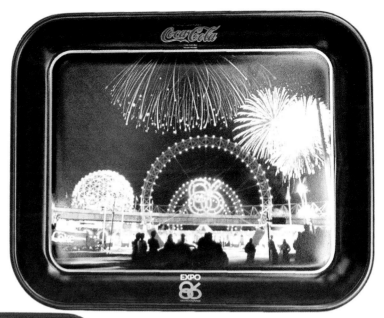

Expo Fireworks
1986
Standard size
Dated, no story
Value: $5

Santa
1986
Standard size
Dated, no story
Value: $10

Festival Park
1986
TV tray
Dated, story on rear
Value: $10

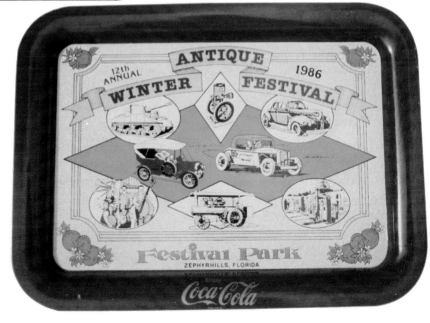

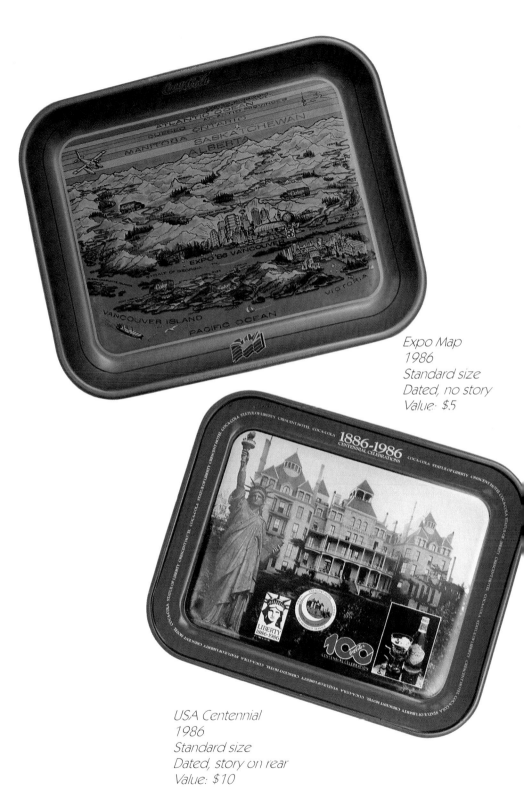

Expo Map
1986
Standard size
Dated, no story
Value: $.5

USA Centennial
1986
Standard size
Dated, story on rear
Value: $10

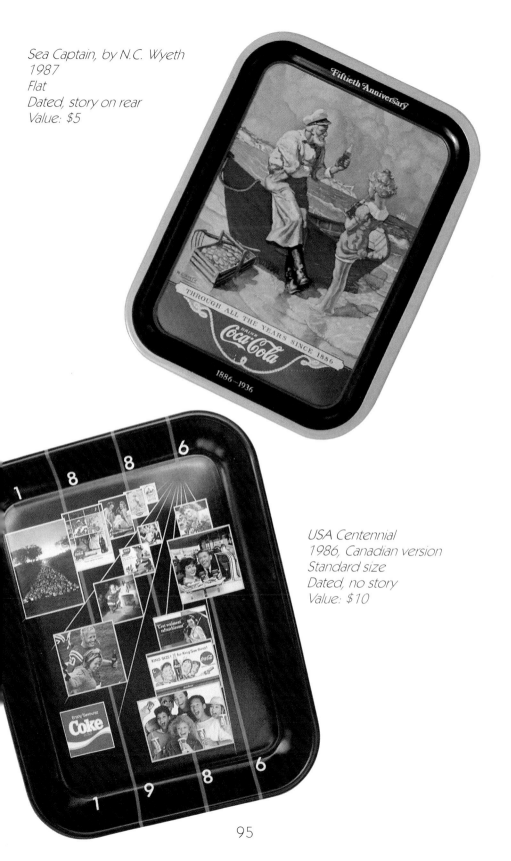

Sea Captain, by N.C. Wyeth
1987
Flat
Dated, story on rear
Value: $5

USA Centennial
1986, Canadian version
Standard size
Dated, no story
Value: $10

95

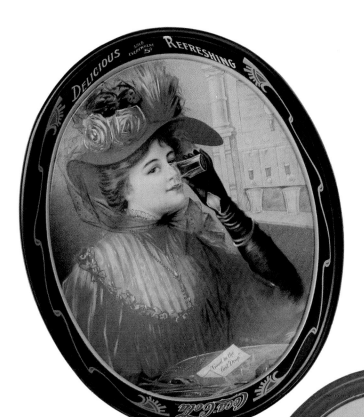

1908 Calendar Girl
1987
Large oval
Dated, story on rear
Value: $5

Santa
1987
Deep oval
Dated, no story
Value: $10

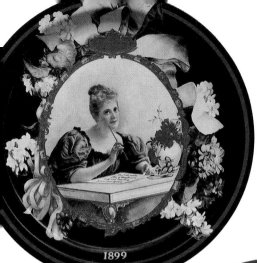

1899 Hilda
1987
Round
Dated, story on rear
Value: $5

Girl at Seashore
1987
Round
No date, no story
Value: $5

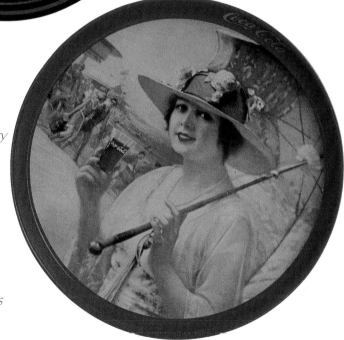

Lady with Pansies
1987
Long rectangle
Dated, no story
Value: $5

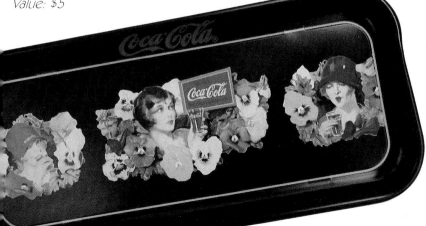

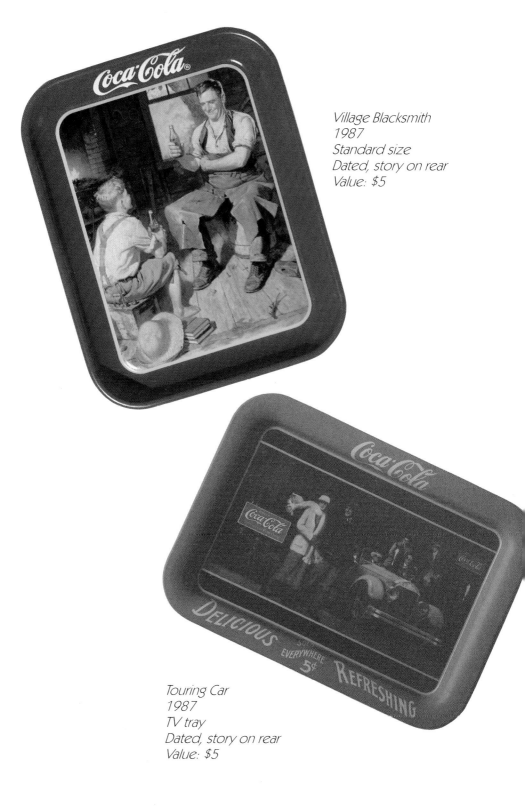

Village Blacksmith
1987
Standard size
Dated, story on rear
Value: $5

Touring Car
1987
TV tray
Dated, story on rear
Value: $5

Calgary Winter Games–XV
Olympics
1988
Standard size
Dated, no story
Value: $15

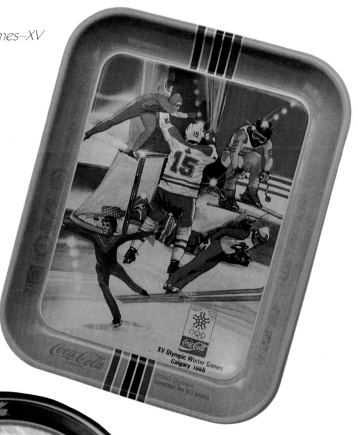

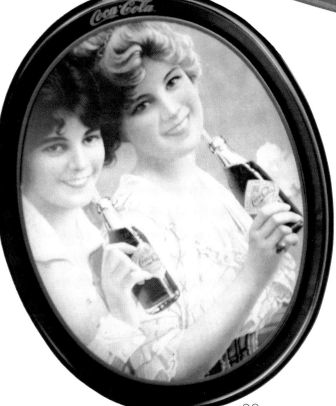

Arkansas 100th
1988
Large oval
Dated
Value: $5

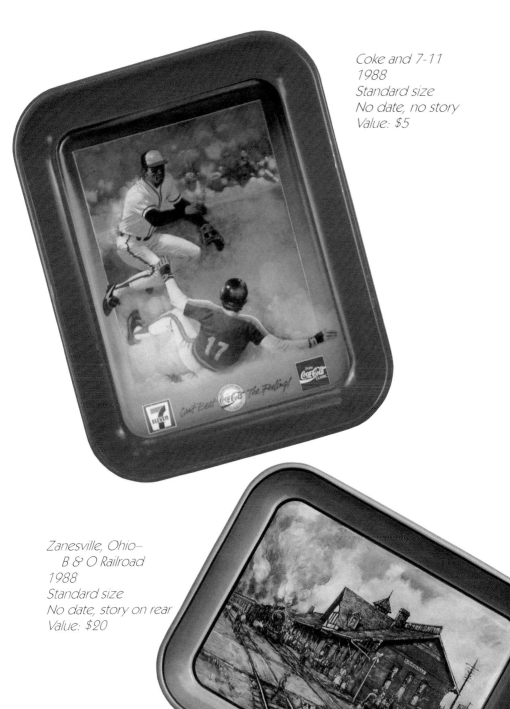

Coke and 7-11
1988
Standard size
No date, no story
Value: $5

Zanesville, Ohio–
 B & O Railroad
1988
Standard size
No date, story on rear
Value: $20

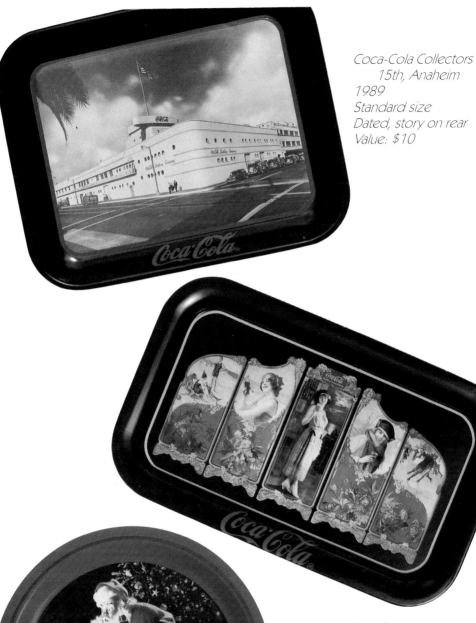

Coca-Cola Collectors
 15th, Anaheim
1989
Standard size
Dated, story on rear
Value: $10

Four Seasons
1989
Small rectangle
Dated, story on rear
Value: $5

Santa–When Friends Drop In
1988
Round
Dated, story on rear
Value: $8

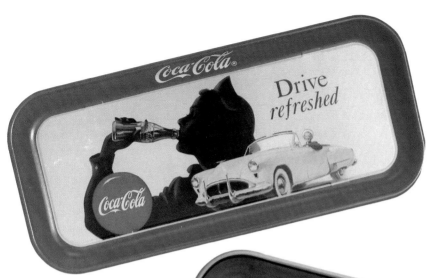

Drive refreshed
1989
Long rectangle
Dated, story on rear
Value: $5

Zanesville, Ohio-
 Market House
1989
Standard size
Dated, story on rear
Value: $20

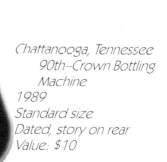

Chattanooga, Tennessee
 90th-Crown Bottling
 Machine
1989
Standard size
Dated, story on rear
Value: $10

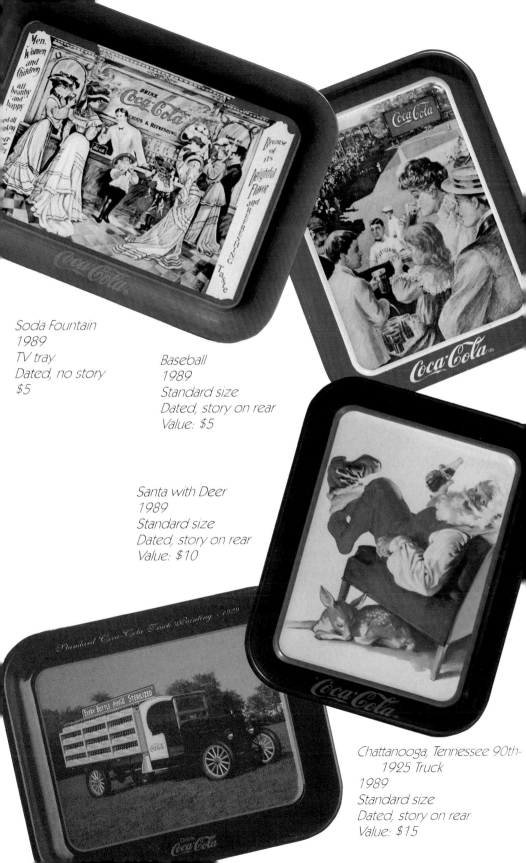

Soda Fountain
1989
TV tray
Dated, no story
$5

Baseball
1989
Standard size
Dated, story on rear
Value: $5

Santa with Deer
1989
Standard size
Dated, story on rear
Value: $10

Chattanooga, Tennessee 90th-
1925 Truck
1989
Standard size
Dated, story on rear
Value: $15

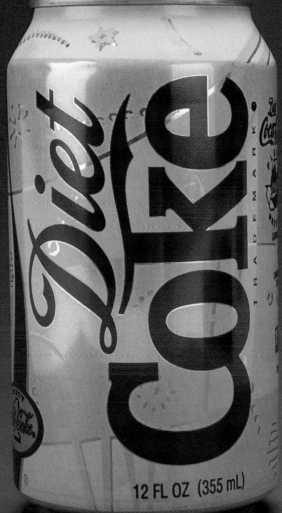

THE
1990S

7 Million a Day
1990
TV tray
Dated, story on rear
Value: $7

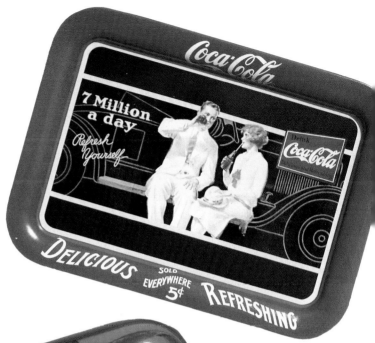

Santa with Bunny
1990
TV tray
Dated, story on
rear
Value: $10

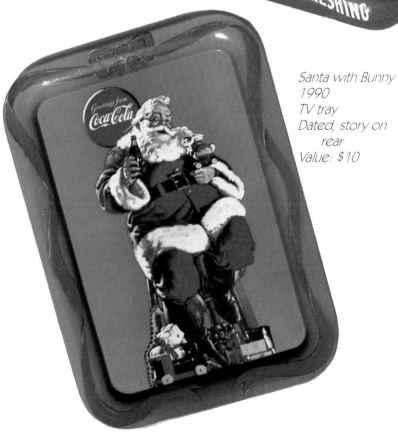

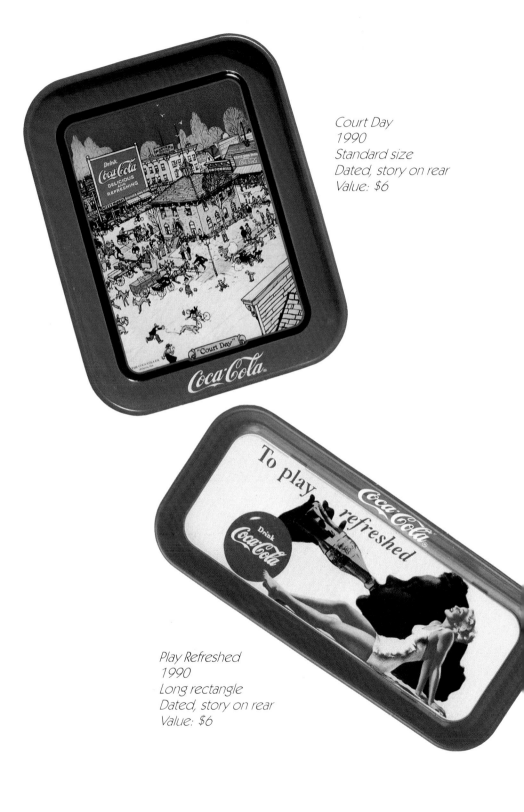

Court Day
1990
Standard size
Dated, story on rear
Value: $6

Play Refreshed
1990
Long rectangle
Dated, story on rear
Value: $6

Barefoot Boy, by Norman Rockwell
1991
Flat
Dated, story on rear
Value: $6

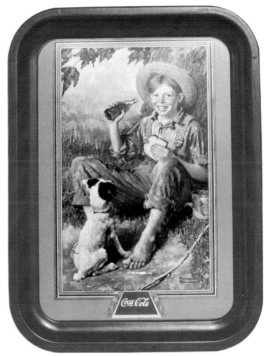

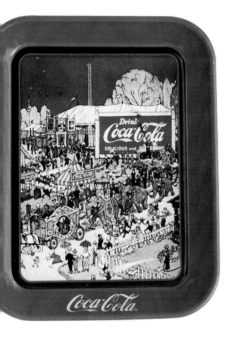

The Circus Comes To Town
1991
Standard size
Dated, story on rear
Value: $6

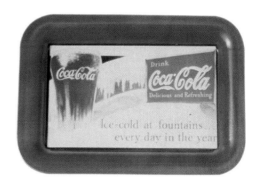

Tip Trays
1991
Authorized
Dated, story on rear
Value: $2 ea.

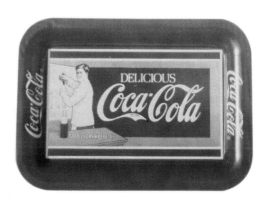

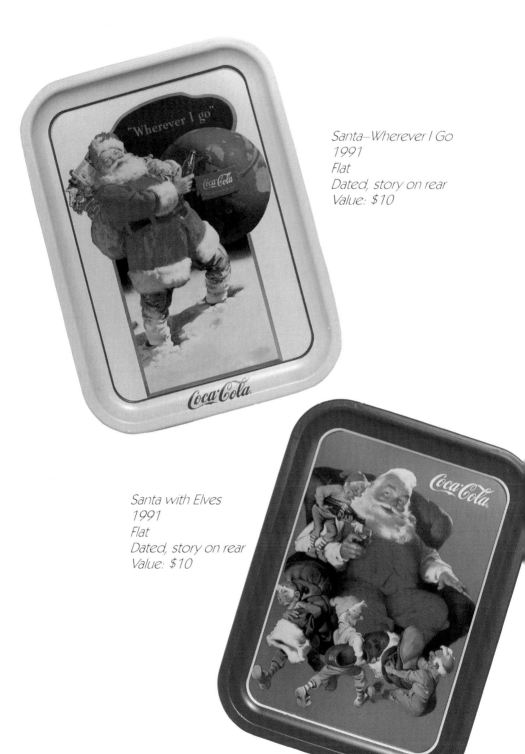

Santa–Wherever I Go
1991
Flat
Dated, story on rear
Value: $10

Santa with Elves
1991
Flat
Dated, story on rear
Value: $10

Pink Calendar Lady
1991
Small rectangle
Dated, story on rear
Value: $6

He's Coming
1991
Flat
Dated, story on rear
Value: $6

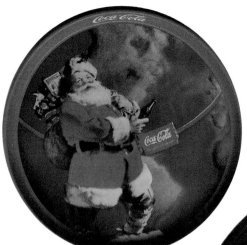

Santa Around the World
1991
Deep round
Dated, story on rear
Value: $6

1912 Calendar Girl
1991
Deep oval
Dated, story on rear
Value: $6

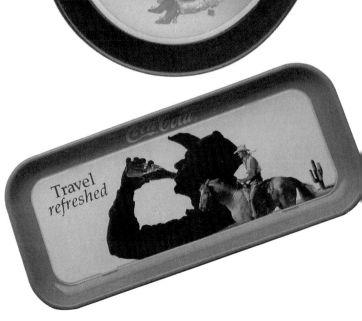

Travel Refreshed
1991
Long rectangle
Dated, story on rear
Value: $6

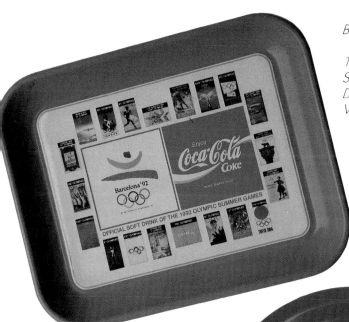

Barcelona 1992
Olympics
1991
Standard size
Dated, story on rear
Value: $10

The Family
1991
Flat round
Dated, story on rear
Value: $6

Welcome
1991
Standard size
Dated, story on rear
Value: $6

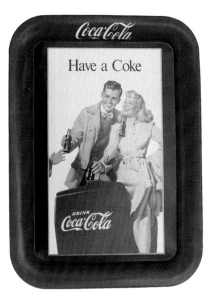

Have a Coke
1991
TV tray
Dated, story on rear
Value: $10

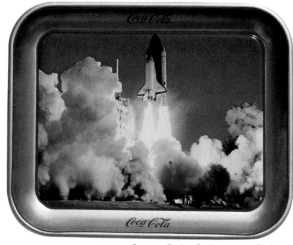

Coca-Cola Collectors Club
18th–Space Shuttle
1992
Standard size
Dated, story on rear
Value: $20

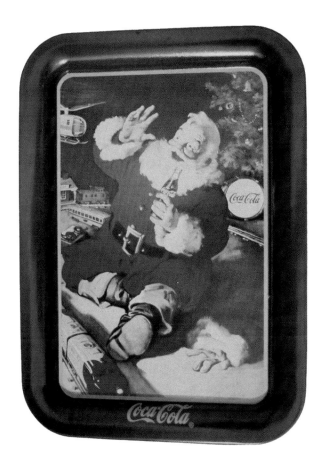

TV Tray
1992
Christmas
Dated, story on rear
Value: $15

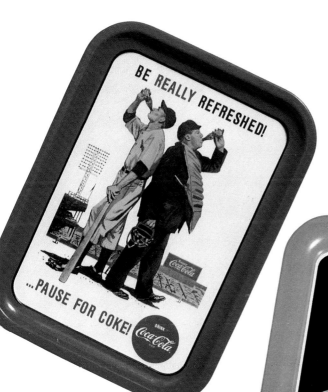

Be Really Refreshed
1992
Flat
Dated, story on rear
Value: $6

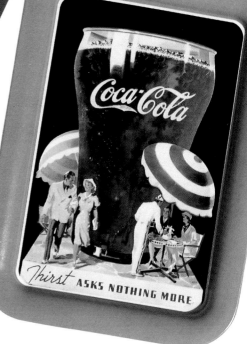

Thirst Asks Nothing More
1992
TV tray
Dated, story on rear
Value: $10

Santa-Season's Greetings
1992
Standars size
Dated, story on rear
Value: $10

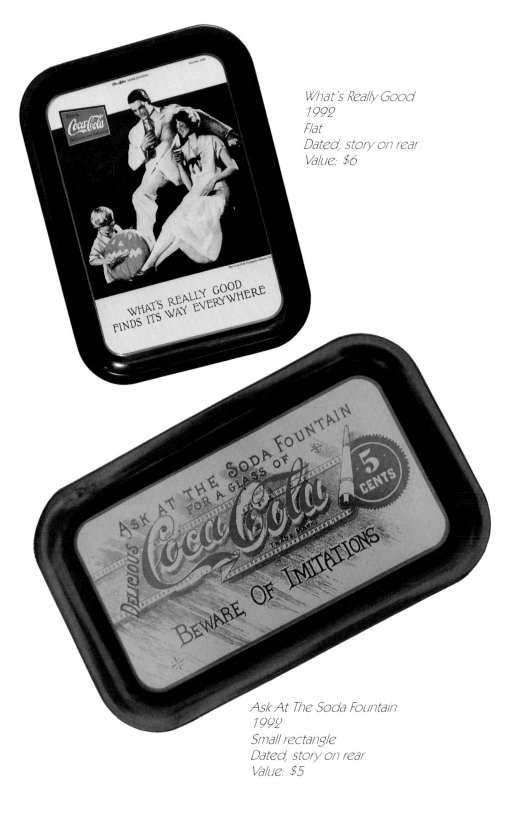

What's Really Good
1992
Flat
Dated, story on rear
Value: $6

Ask At The Soda Fountain
1992
Small rectangle
Dated, story on rear
Value: $5

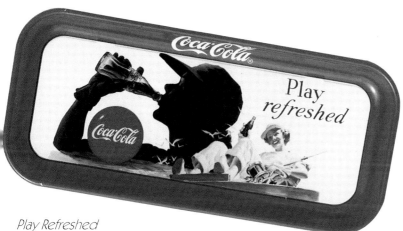

Play Refreshed
1992
Standard size
Dated, story on rear
Value: $6

Santa
1992
Flat round
Dated, story on rear
Value: $6

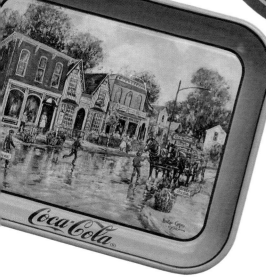

Zanesville, Ohio–Dresden Village
1992
Standard size
No date; story on rear
Value: $20

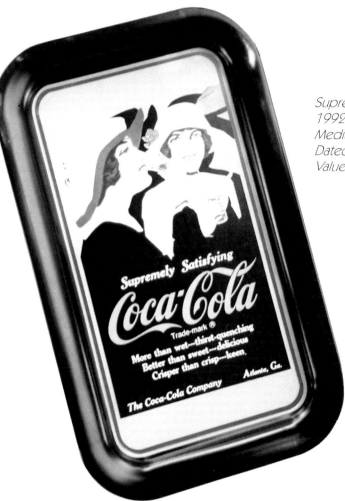

Supremely Satisfying
1992
Medium rectangle
Dated, story on rear
Value: $5

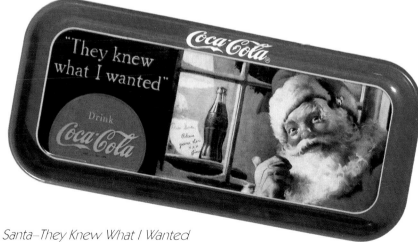

Santa–They Knew What I Wanted
1992
Standard size
Dated, story on rear
Value: $6

Always Coca-Cola
1993
Deep round
Dated, no story
Value: $20

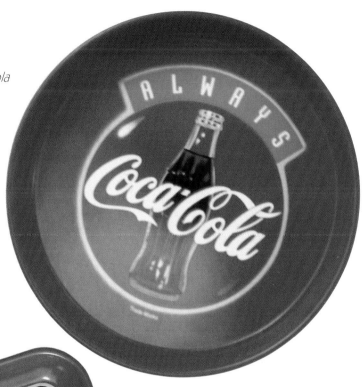

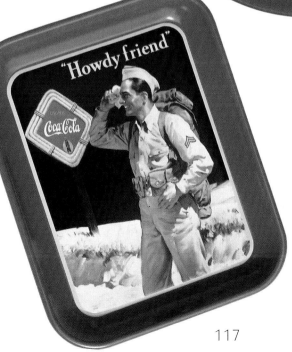

Howdy Friend
1992
Standard size
Dated, story on rear
Value: $5

Boys on the Curb
1993
Small flat
Dated, story on rear
Value: $6

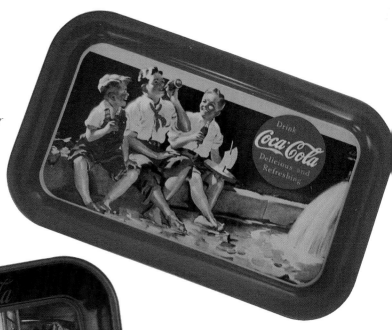

Whaddya Know
1993
Standard size
Dated, story on rear
Value: $6

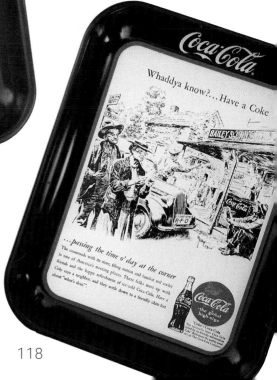

Reflections in a Mirror
1993
Standard size
Dated, story on rear
Value: $7

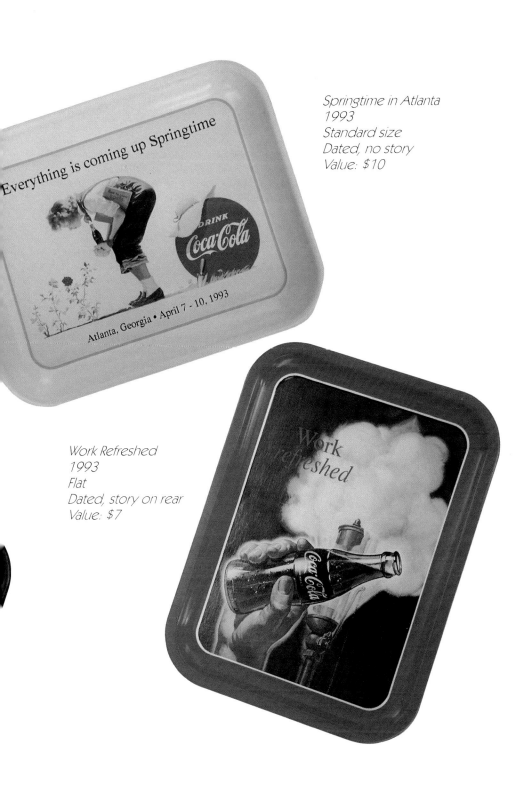

Everything is coming up Springtime

DRINK
Coca-Cola

Atlanta, Georgia • April 7 - 10, 1993

Springtime in Atlanta
1993
Standard size
Dated, no story
Value: $10

Work Refreshed
1993
Flat
Dated, story on rear
Value: $7

Work
refreshed

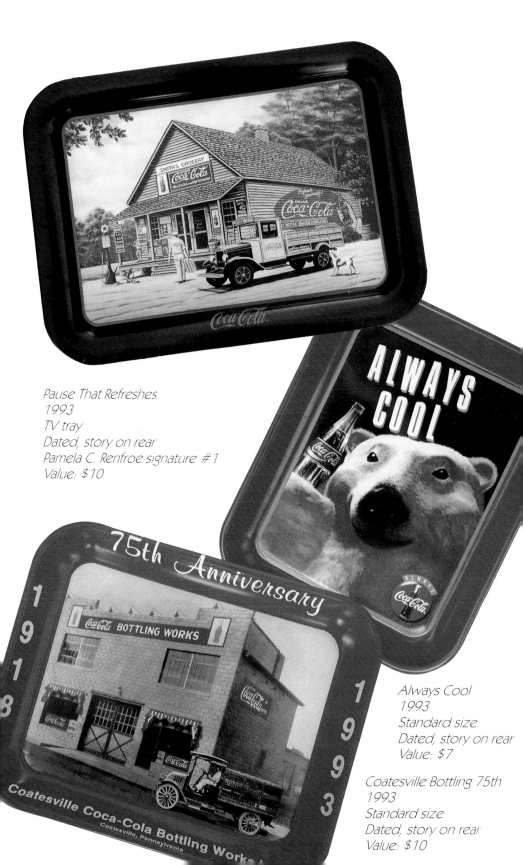

Pause That Refreshes
1993
TV tray
Dated, story on rear
Pamela C. Renfroe signature #1
Value: $10

Always Cool
1993
Standard size
Dated, story on rear
Value: $7

Coatesville Bottling 75th
1993
Standard size
Dated, story on rear
Value: $10

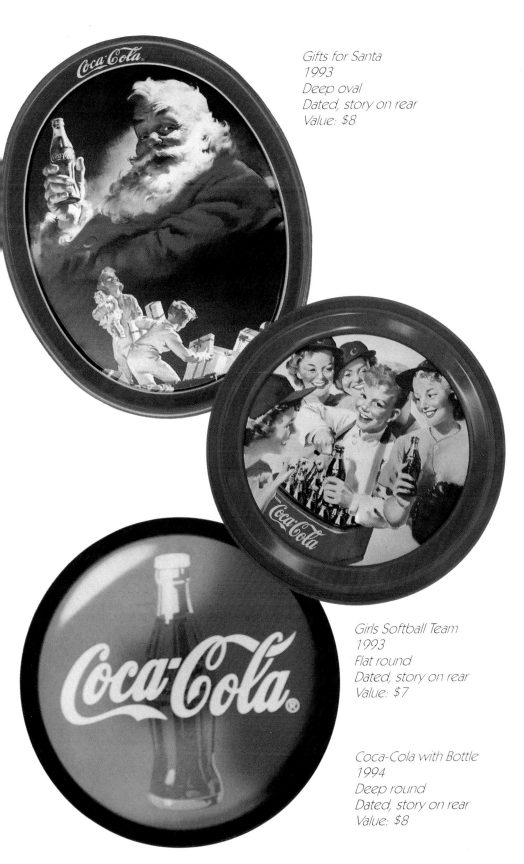

Gifts for Santa
1993
Deep oval
Dated, story on rear
Value: $8

Girls Softball Team
1993
Flat round
Dated, story on rear
Value: $7

Coca-Cola with Bottle
1994
Deep round
Dated, story on rear
Value: $8

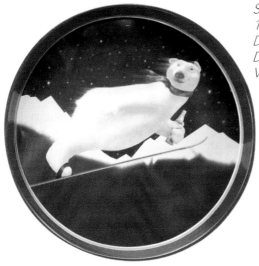

Skiing Bear
1994
Deep round
Dated, no story
Value: $5

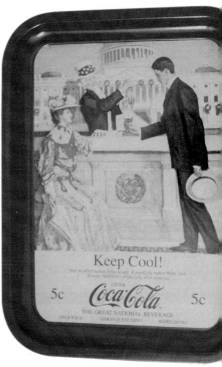

Keep Cool
1994
Flat tray
Value: $8

Sign of Good Taste
1994
Standard size
Dated, story on rear
Pamela C. Renfroe signature #2
Value: $10

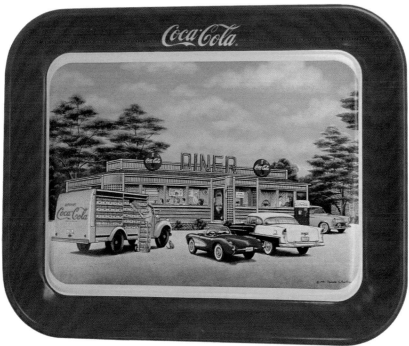

Thrift Mercantile
1994
Standard size
Dated, story on rear
Jeanne Mack signature
Value: $8

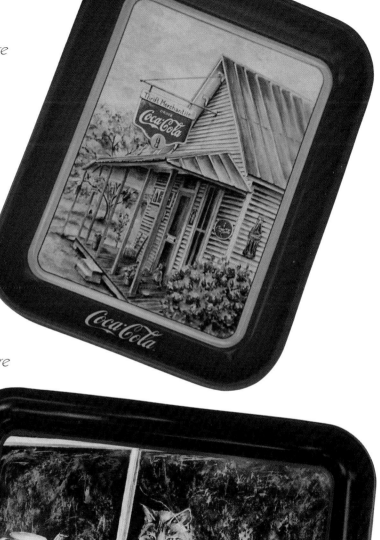

Cat in a Window
1994
TV tray
Dated, story on rear
Jeanne Mack signature
Value: $8

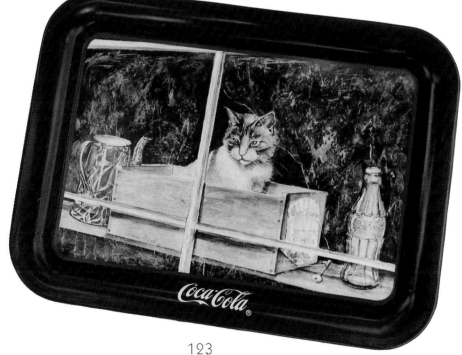

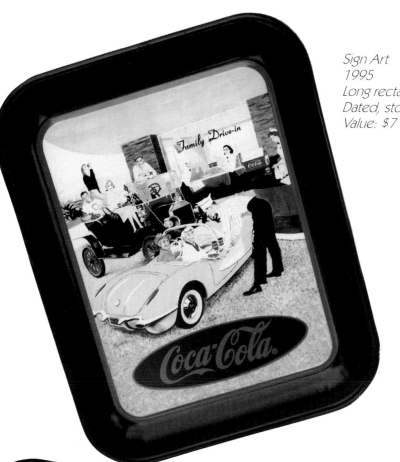

Sign Art
1995
Long rectangle
Dated, story on rear
Value: $7

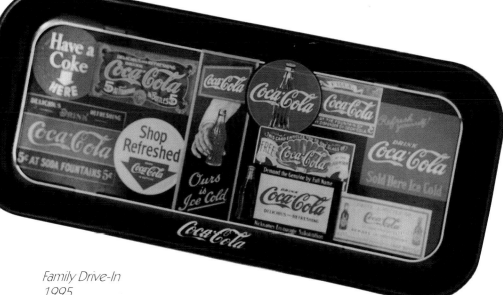

Family Drive-In
1995
Standard size
Dated, story on rear
Value: $7

Mailboxes
1995
Deep oval
Dated, story on rear
Jeanne Mack signature
Value: $8

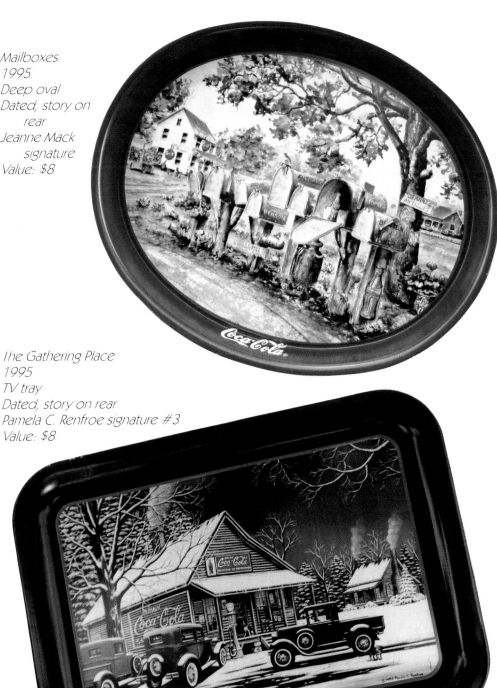

The Gathering Place
1995
TV tray
Dated, story on rear
Pamela C. Renfroe signature #3
Value: $8

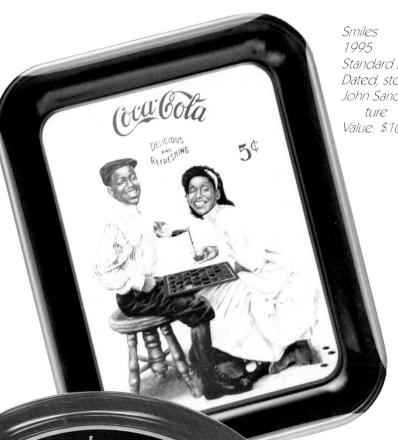

Smiles
1995
Standard size
Dated, story on rear
John Sandridge signature
Value: $10

Santa–Thanks for the Pause
1995
Small oval
Dated, story on rear
Value: $5

Shop Refreshed
1995
Long rectangle
Dated, story on rear
Value: $8

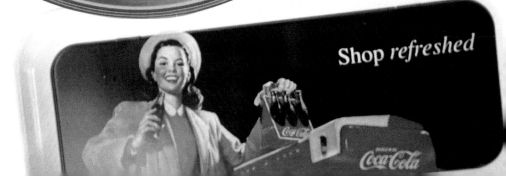

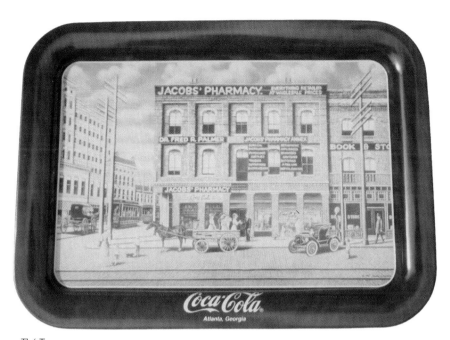

TV Tray
1995
Dated, story on rear
Value: $10

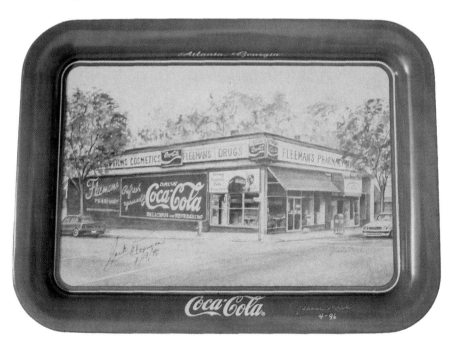

TV Tray
1995
Dated, story on rear
Value: $10

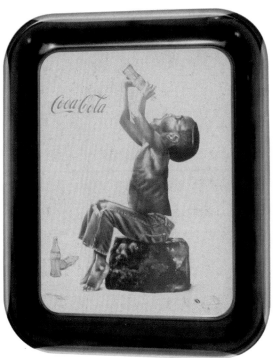

Last Drip
1996
3rd in series
Regular size
Value: $8

Birthday Smiles
1996
2nd in series
Regular size
Value: $8
Standard size
Value: $250

The Varsity, TV Tray
1996
Dated, story on rear
Value: $15

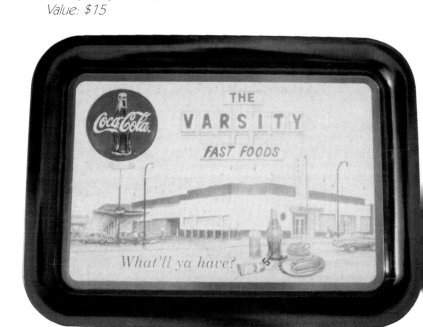